THE PAPER DOLLS OF

Zelda F. Fitzgerald

ELEANOR LANAHAN

SCRIBNER

New York London Toronto Sydney New Delhi

Scribner
An Imprint of Simon & Schuster, Inc.
1230 Avenue of the Americas
New York, NY 10020

First Scribner hardcover edition November 2022

SCRIBNER and design are registered trademarks of The Gale Group, Inc.,
used under license by Simon & Schuster, Inc., the publisher of this work.

For information about special discounts for bulk purchases, please contact
Simon & Schuster Special Sales at 1-866-506-1949 or business@simonandschuster.com.

The Simon & Schuster Speakers Bureau can bring authors to your live event. For more information or to book an event,
contact the Simon & Schuster Speakers Bureau at 1-866-248-3049 or visit our website at www.simonspeakers.com.

Jacket and book design by Tina Christensen

Manufactured in China

1 3 5 7 9 10 8 6 4 2

Library of Congress Cataloging-in-Publication Data

Names: Lanahan, Eleanor Anne, 1948– author.
Title: The paper dolls of Zelda Fitzgerald / Eleanor Lanahan.
Description: First Scribner hardcover edition. | New York : Scribner, 2022.
Identifiers: LCCN 2021043166 (print) | LCCN 2021043167 (ebook) | ISBN 9781982187194 (hardcover) | ISBN 9781982187200 (ebook)
Subjects: LCSH: Fitzgerald, Zelda, 1900–1948—Themes, motives. | Paper dolls—United States—Themes, motives.
Classification: LCC NK8553.5.F58 L36 2022 (print) | LCC NK8553.5.F58 (ebook) | DDC 745.592/21092—dc23/eng/20211206
LC record available at https://lccn.loc.gov/2021043166
LC ebook record available at https://lccn.loc.gov/2021043167

ISBN 978-1-9821-8719-4
ISBN 978-1-9821-8720-0 (ebook)

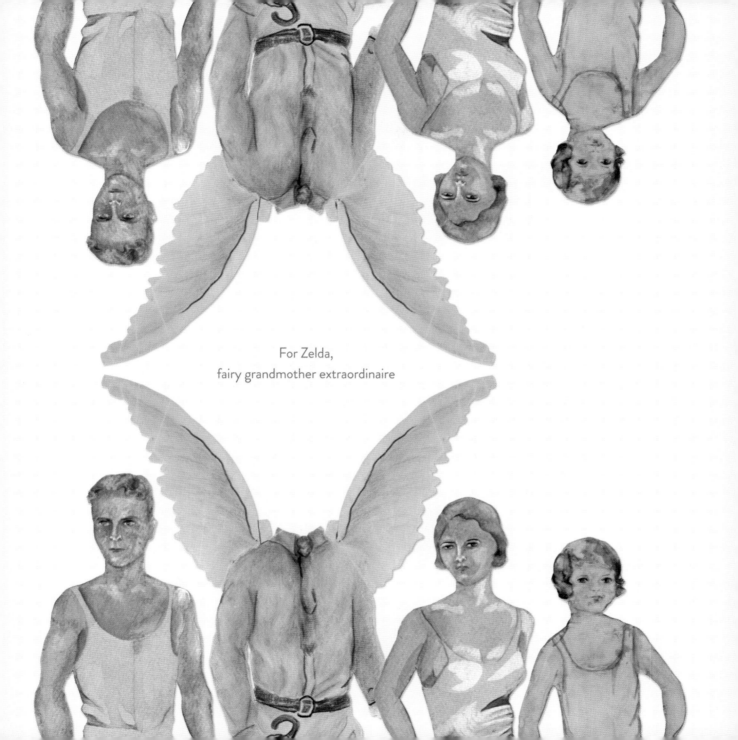

For Zelda,
fairy grandmother extraordinaire

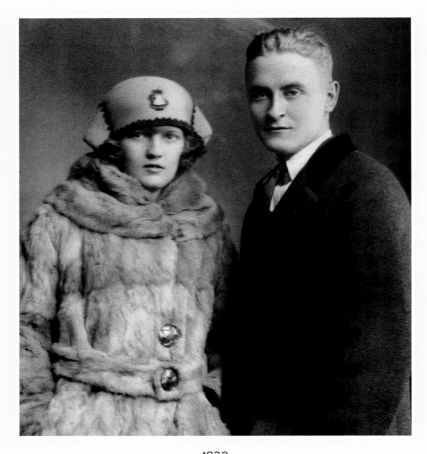

1920

Scott and Zelda in the first year of their marriage

Contents

Preface / ix

Interest in Zelda's paper dolls came late. In 1959, when *Life* magazine photographed Zelda's daughter, Scottie
Fitzgerald Lanahan, viewing some of these paper dolls in her attic, the public's interest in F. Scott and Zelda
Fitzgerald had begun a resurgence. Despite this publicity, for decades most of the dolls remained in storage.
Others were scattered in various collections. Now they are together for the first time.

A Brief History / 1

The paper dolls are best understood in the context of Zelda's life and times, from 1900 to 1948. Here is an account
of the important events in her lifetime: her marriage to F. Scott Fitzgerald; the birth of her daughter, Scottie;
writing; travel; dance; illness; and ultimate artistic blossoming.

The Dolls / 17

A presentation of practically every doll known to have been created by Zelda Fitzgerald, grouped
according to their stories, with explanations whenever possible. The dolls show Zelda's intimate knowledge of the
human form, a command of period costume, and the virtuosity of a serious artist.

Above

A cutout photo doll of Scott and Zelda's daughter, Scottie. Made in Paris about 1926.

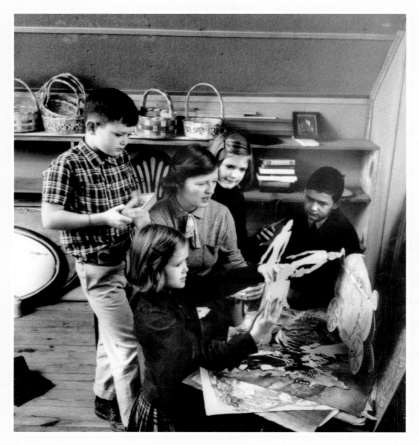

February 16, 1959

Scottie Fitzgerald Lanahan in the attic of her home in Washington, DC, showing Zelda's paper dolls to her four children, clockwise from Samuel (standing), Eleanor (the author), Tim, and Cecilia, for a story in *Life* magazine.

Preface

For decades, Zelda Sayre Fitzgerald was known primarily as F. Scott Fitzgerald's wife and highly quotable sidekick, the original Roaring Twenties flapper and model for many of her husband's fictional heroines. With the women's movement in the late 1960s came a resurgence of interest in Zelda's own talents as a writer of fiction and as a dancer. But until recently, few people were aware of her artwork, although she produced more than one hundred cityscapes of the places where she lived, illustrations for fairy tales and biblical stories, and paintings of figures and flowers. For me, though— her granddaughter—the showstoppers were always her paper dolls.

There were no photographs of my grandparents around the house when I was growing up, but Scott and Zelda were an unspoken presence. Zelda's cityscape paintings hung downstairs, and her fairy-tale illustrations in our bedrooms. She died only two months after I was born. In her last letter to my mother, she wrote: "I long to meet the baby girl: is she fair or dark, of epic or lyric disposition?" How I wish I had met her! I do, however, find consolation in knowing she was aware of my existence.

The first personal connection I made with my grandmother was when I discovered she had painted these vibrant paper dolls. At around the age of ten, I found them in an attic closet, stored in tattered cardboard portfolios. These secret treasures were like Christmas cookies—they lay, one on top of the other, slightly tangled, and tantalizing. I was too old to play with them, but I enjoyed visiting them occasionally.

My grandfather Scott had died in 1940, nearly forgotten by his public at that time. During the Great Depression his books had essentially fallen out of print. A Fitzgerald revival began in the 1940s, when special armed services editions of *The Great Gatsby* were distributed to U.S. troops in World War II. By the 1950s his novels and stories were being included in college curricula. In 1959, *Life* magazine came to our house to take photographs for a story they planned to run, "The Spell of F. Scott Fitzgerald Grows Stronger." We four grandchildren spent an afternoon with our mother in the attic, exploring Zelda's ostrich-feather fans, Scott's lead soldiers, boxes of letters, some first editions, and Zelda's paper dolls. When the story appeared, I realized I was related to a famous person, but, despite the resurging publicity for F. Scott, the dolls remained in storage.

Perhaps this dormancy period was positive. After many years, Zelda's contribution to the arts, in her own right, has been recognized. And here, in these playthings, my grandmother is compellingly alive. This collection harkens to a pre-digital age when a brushstroke was personal, a signature. The figures and their finery manifest her excitement about dance, color, story, costume, and play.

All the dolls are sketched in pencil on illustration board and painted in gouache, the brilliant opaque watercolor Zelda used so courageously. Their costumes are painted on a lighter, medium-weight art paper. Most have been cut out from their backgrounds, but some, like King Arthur's court, Hansel & Gretel, and several assorted dolls, remain intact. The dolls are generally about twelve inches tall. If their costumes

include bonnets, scarves, crowns, or helmets, they may reach fourteen inches. The shortest is Baby Bear (page 29), who stands at nine.

Almost every doll has at least one change of costume. The skinny Cardinal Richelieu (page 39), in bright red underwear with a blazing red cassock, is my particular favorite. The ones Zelda created later have more extensive wardrobes. Men are usually outfitted with battle attire as well as ceremonial dress and embody the splendors of eras past. The women are unapologetically muscular, and sometimes the men are boldly androgynous—if Papa Bear desires a party dress, he shall have it! With heads uplifted, captured in their balletic poses, they are emissaries from the land of make-believe, waiting for the curtain to rise.

This book is the culmination of decades of small discoveries about the dolls, their costumes, and their groupings. A few of them are missing, which haunts me. They are fragile; limbs have fallen off, a shoe is lost, a wing has vanished. The dolls, themselves, are being scattered as we grandchildren pass them along to the next generation. But here, for the first time, almost every known member of the troupe is assembled and dressed to dazzle. I hope you find them as fascinating and beautiful as I do, and as imbued with Zelda Fitzgerald's impetuous spirit.

—Eleanor Lanahan

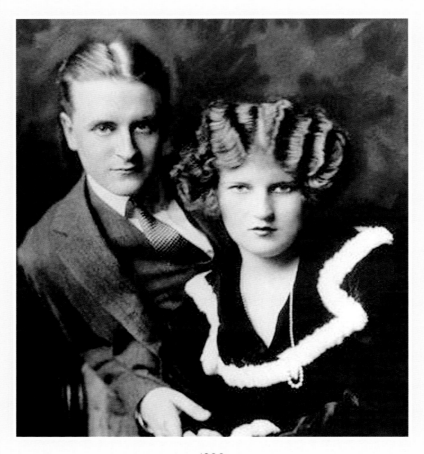

1920

—

Zelda and Scott

A Brief History

Zelda Sayre arrived with the new century on July 24, 1900, in Montgomery, Alabama. Her father was a respected judge, and her mother was a stay-at-home raconteuse who delighted in Zelda, her fifth child. By the age of eighteen, Zelda was a flirtatious belle, beautiful, graceful, and daring. She met Francis Scott Fitzgerald in the summer of 1918 at a country-club dance in Montgomery near Fort Sheridan, where he was stationed during World War I. Their romance burgeoned into an engagement, although Scott—a penniless aspiring author, and a Yankee to boot—was deemed a poor prospect for a husband.

The South was still reeling economically from the Civil War, and many young girls were encouraged to find husbands who could promise financial security. At her family's insistence, Zelda broke off the engagement. At least one of Scott's friends hinted that Zelda might, likewise, be an unsuitable spouse. Scott replied, "I fell in love with her courage, her sincerity, and her flaming self-respect, and it's these things I'd believe in even if the whole world indulged in wild suspicions that she wasn't all that she should be. . . . I love her and that's the beginning and end to everything."

Then, in 1920, with the publication and instant success of Scott's first novel, *This Side of Paradise*, Zelda caught a train to New York City and married the newly acclaimed author F. Scott Fitzgerald in St. Patrick's Cathedral.

They joined the celebratory mood of postwar America and became darlings of

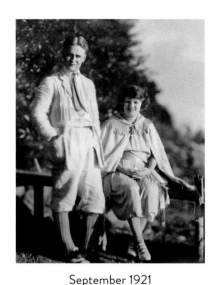

September 1921

Scott and Zelda in St. Paul, Minnesota,
just before the birth of their daughter,
Scottie

the Jazz Age, an era that Scott named. In his novels and short stories, Scott captured an essential American spirit and chronicled his age. The twenties, in Scott's words, were "the greatest, gaudiest spree in history." Zelda, for her part, was the original flapper: she danced, she smoked, and she drank. Together the couple sprang atop a taxi on Fifth Avenue, plunged into the fountain in front of the Plaza Hotel, and rode the crest of a great economic boom. Their energy, eloquence, and high jinks led Scott to reminisce, "We felt like small children in a great bright unexplored barn."

At times Zelda served as Scott's muse; her diaries and letters inspired several passages in his work. Zelda published magazine articles of her own, sometimes sharing a byline with Scott so they could command a higher fee. In her article "Eulogy on a Flapper," in 1922, she announced summarily that "the flapper is deceased." After two years, she felt, the flapper style was commonplace. The toppling of Victorian mores was accomplished.

By early 1921, Zelda was pregnant. For some months the Fitzgeralds rented a house in Westport, Connecticut, and then made a quick trip to Europe. For the birth of the baby they moved to St. Paul, Minnesota, Scott's hometown, where my mother, Scottie, was born in October 1921. She was Scott and Zelda's only child. Before her first birthday, the family had moved again, this time to Long Island.

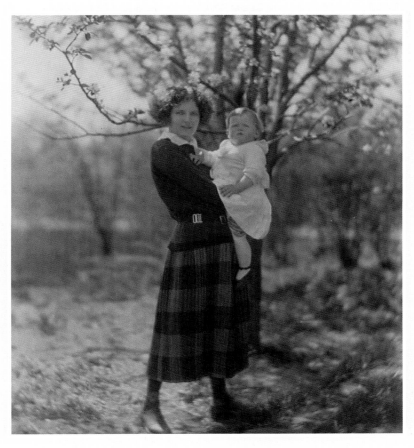

1922

Zelda with Scottie at 6 Gateway Drive, Great Neck, Long Island

Here, Harper & Brothers asked Zelda to contribute to a cookbook anthology, *Favorite Recipes of Famous Women*. She wrote:

> See if there is any bacon, and if there is ask the cook which pan to fry it in. Then ask if there are any eggs, and if so try and persuade the cook to poach two of them. It is better not to attempt toast, as it burns very easily. Also, in the case of bacon do not turn the fire too high, or you will have to get out of the house for a week.

In 1924, to escape Prohibition and the high cost of living, the Fitzgeralds sailed for France. Besides, Zelda explained, "I hate a room without an open suitcase in it; it seems so permanent."

Their first destination was Saint-Raphaël on the Côte

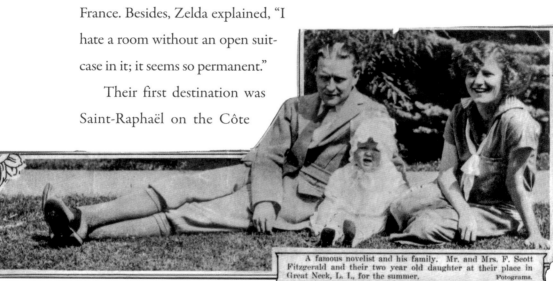

A famous novelist and his family. Mr. and Mrs. F. Scott Fitzgerald and their two year old daughter at their place in Great Neck, L. I., for the summer. *Fotograms.*

1922
—

Scott and family after publication of his second novel, *The Beautiful and Damned*.

d'Azur. The beaches of the Riviera were populated by artists and creative expatriates: Sara and Gerald Murphy, Pablo Picasso, Fernand Léger, Georges Braque, Cole Porter, and Ernest Hemingway. "One could get away with more on the summer Riviera," Scott wrote his editor, Maxwell Perkins, "and whatever happened seemed to have something to do with art."

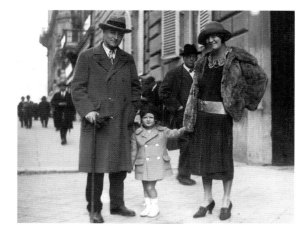

Winter 1924

The Fitzgerald family in Rome

It was a heady world. With Scott absorbed in writing *The Great Gatsby*, Zelda began to yearn for an artistic identity of her own. A nanny sheltered Scottie from the zany escapades of her parents; from Zelda's flirtation with a French aviator, and from Scott's ever-increasing drinking.

The family spent the winter of 1924 in Italy. They rented a villa on the island of Capri, where Zelda painted and Scott made final revisions to *Gatsby*. By April 1925, the Fitzgeralds were settled in Paris. Zelda attended ballets, which stirred a strong desire for an entrée into the world of dance.

Early Dolls

In December 1926, in quest of surroundings more conducive to writing, the family returned to America and spent a year at Ellerslie, a rented estate in Delaware. "The

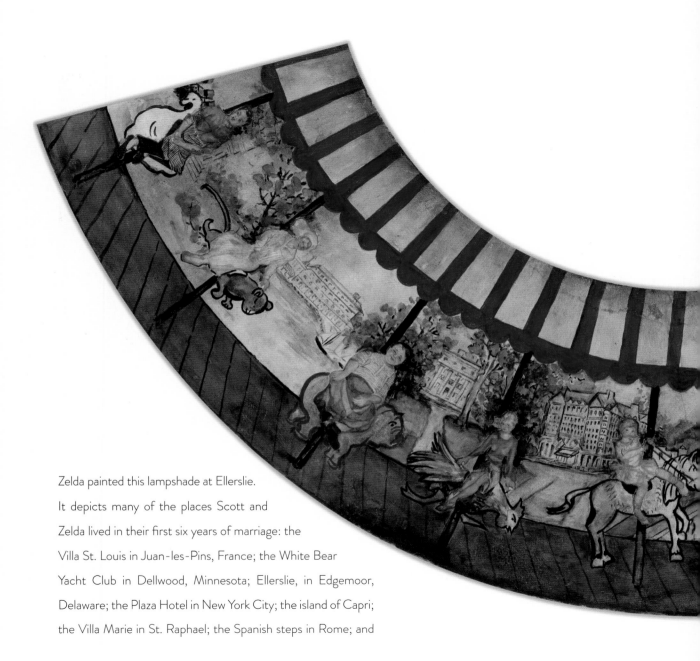

Zelda painted this lampshade at Ellerslie. It depicts many of the places Scott and Zelda lived in their first six years of marriage: the Villa St. Louis in Juan-les-Pins, France; the White Bear Yacht Club in Dellwood, Minnesota; Ellerslie, in Edgemoor, Delaware; the Plaza Hotel in New York City; the island of Capri; the Villa Marie in St. Raphael; the Spanish steps in Rome; and

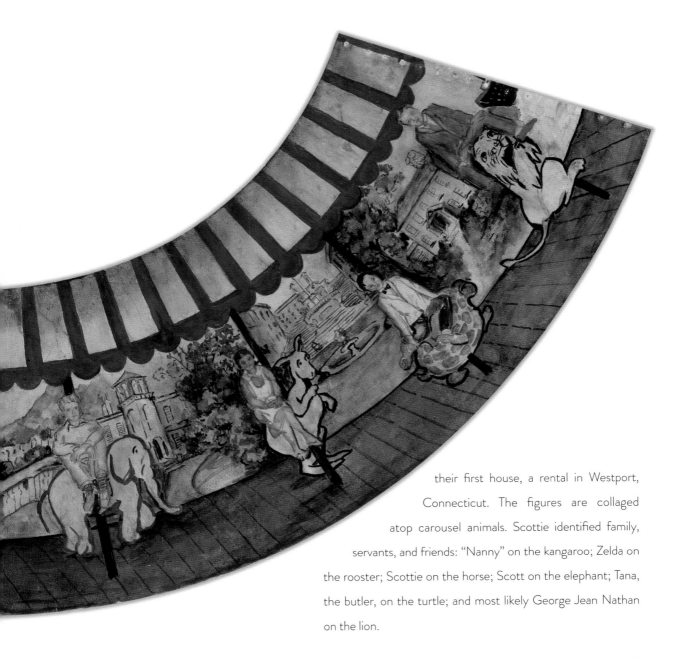

their first house, a rental in Westport, Connecticut. The figures are collaged atop carousel animals. Scottie identified family, servants, and friends: "Nanny" on the kangaroo; Zelda on the rooster; Scottie on the horse; Scott on the elephant; Tana, the butler, on the turtle; and most likely George Jean Nathan on the lion.

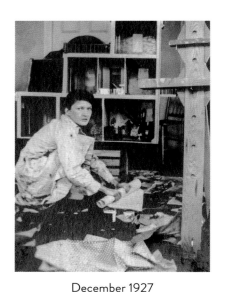

December 1927

Zelda making a dollhouse for Scottie,
Ellerslie

squareness of the rooms," Zelda wrote, "and the sweep of the columns were to bring us a judicious tranquility."

She also made her first sets of paper dolls for Scottie. Unfortunately, many of those early dolls, intended as playthings, do not survive.

"It is characteristic of my mother," Scottie wrote, "that these exquisite dolls, each one requiring hours of artistry, should have been created for the delectation of a six-year-old. Some of the paper dolls represented the three of us. Once upon a time these dolls had wardrobes of which Rumpelstiltskin could be proud. My mother and I had dresses of pleated wallpaper, and one party frock of mine had ruffles of real lace cut from a Belgian handkerchief. More durable were the ball dresses of Mesdames de Maintenon and Pompadour and the coats-of-mail of Galahad and Lancelot, for these were lavishly painted in the most minute detail in watercolor so thick that it has scarcely faded. Perfectly preserved are the proud members of the courts of both Louis XIV and King Arthur (figures of haughty mien and aristocratic bearing), a jaunty Goldilocks, an insouciant Red Riding Hood, an Errol Flynn–like D'Artagnan, and other personages familiar to all little well-instructed boys and girls of that time."

The Fitzgeralds were restless in Delaware and returned to France in 1928, sixteen months later. Scott was reworking his fourth novel, *Tender Is the Night*, while

Zelda, at the late age of twenty-eight, began rigorous classes with Lubov Egorova, a Russian émigré dance teacher who directed the Diaghilev School of Ballet, named for Sergei Diaghilev, founder and director of the famed Ballet Russes. With obsessive intensity, Zelda threw all her creative energy into dance. She described this arduous training in her novel, *Save Me the Waltz*:

> At night she sat in the window too tired to move, consumed by a longing to succeed as a dancer. It seemed to Alabama that, reaching her goal, she would drive the devils that had driven her—that, in proving herself, she would achieve that peace which she imagined went only in surety of one's self—that she would be able, through the medium of the dance, to command her emotions, to summon love or pity or happiness at will, having provided a channel through which they might flow. She drove herself mercilessly.

In 1930, Zelda was offered a small solo in the San Carlo Opera Ballet Company in Italy; for reasons unknown, she declined. It was on a trip she took to Algeria with Scott that she experienced early signs of mental illness. Within a month she was hospitalized at the Prangins Clinic in Switzerland, a mental-health facility directed by Dr. Oscar Forel. Heartrending though it was, Zelda relinquished her dream of becoming a professional ballerina. And as part of her treatment, Zelda's doctors advised Scott to return to Paris. Forel then invited Carl Jung and Eugen Bleuler to consult on the case. Zelda was diagnosed with the recently identified condition of schizophrenia.

1931

—

Postcard from the Prangins Clinic

"I don't need anything except hope," she wrote Scott, "which I can't find by looking backwards or forwards, so I suppose the thing is to shut my eyes."

As Zelda slowly improved, she explained the onset of her illness:

In Paris, before I realized that I was sick, there was a new significance to everything: stations and streets and facades of buildings—colors were infinite, part of the air, and not restricted by the lines that encompassed them and lines were free of the masses they held. There was music that beat behind my forehead and other music that fell into my stomach from a high parabola and there was some Schumann that was still and tender. . . . Then the world became embryonic in Africa—and there was no need for communication. The Arabs fermenting in the vastness; the curious quality of their eyes and the smell of ants; a detachment as if I was on the other side of black gauze. . . .

Each decade of Scott and Zelda's life together paralleled the changing fortunes of America. Throughout the twenties my grandparents led fairy-tale lives, with an abundance of romance, travel, and lively company. But by 1930, and the start of the Great Depression, their fairy tale had ended.

Scott's alcoholism was now full-blown. With the onset of the Depression, the fees paid by the magazines for stories, the family's bread and butter, plummeted to a tenth of what they had been previously. *Tender Is the Night* was four years from publication. Scott borrowed money from his agent for Zelda's hospitalizations and my mother's schooling. Thus began a cycle of borrowing money followed by desperate efforts to write himself out of debt.

With Zelda's illness in fragile remission, in the fall of 1931, the Fitzgeralds returned to the United States. Within five months she relapsed and entered Phipps Psychiatric Clinic in Baltimore, part of Johns Hopkins Hospital. In less than two months, as an inpatient, she wrote an entire novel, *Save Me the Waltz*. A now-famous marital dispute ensued about Scott and Zelda's shared biographical material. Zelda used story lines that overlapped with Scott's stalled novel. She named one character Amory Blaine, after a character in Scott's first novel. And the protagonist of Zelda's novel, Scott charged, was a faintly veiled portrait of him. Her novel, in Scott's estimation, would ruin them both. Zelda acquiesced. When the novel was trimmed, with Scott's help, it was

1932

———

The Fitzgeralds rented La Paix in Baltimore while Zelda was a patient at Johns Hopkins.

Summer 1933

Zelda and Scottie, from the society pages of the *Baltimore Sun*

much improved, but its abundance of metaphor led some critics to consider it more of a prose poem than a novel.

This episode has provided endless fodder to Zelda's champions who claim her talents were suppressed by her husband. But the record shows he not only encouraged her to write, he championed her. Scott wrote Maxwell Perkins that Zelda was a "true original" and described her novel as "an expression of a powerful personality." Later, to her psychiatrist Dr. Slocum at Craig House in Beacon, New York, he wrote, "She has made marked successes in short character studies and has an extraordinary talent for metaphor and simile."

When *Save Me the Waltz* sold a modest two thousand copies, Zelda turned to playwriting. *Scandalabra* was a three-hour farce, written by Zelda and, at the last minute, shortened and directed by Scott. It had a six-night run in Baltimore. Following these endeavors, Zelda turned her talents to painting.

After six years of various treatments, in 1936 Zelda was hospitalized at Highland Hospital in Asheville, North Carolina. In 1937, Scott took a badly needed job with MGM in Los Angeles. He had, at last, stopped drinking. In the dark days of the Depression he worked in the infamous screenwriting factory, where he adapted and doctored scripts. "I wish I was in print," he wrote Perkins in 1940.

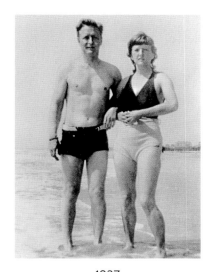

1937

Scott and Zelda vacationing in Isle of Palms, South Carolina

"It will be odd a year or so from now when Scottie assures her friends that I was an author and finds that no book is procurable."

In February 1939, Zelda accompanied Dr. Robert Carroll, the director of Highland Hospital, and his wife to Sarasota, Florida, where she took a monthlong course in costume design and life drawing at the Ringling School of Art. Later that year she exhibited with the Asheville Artists' Guild.

Scott died suddenly of heart failure in December 1940, at the age of forty-four. He had repaid his debts and had just enough money hidden in a book to cover the cost of his funeral. Zelda survived on a small veteran's pension from Scott's service during World War I.

She hoped to sell some of her art for "pin money." Scottie, then a reporter at *The New Yorker*, tried to sell some of her mother's work at the Women's Exchange, but whenever she asked Zelda to send landscapes, she supplied religious paintings, which Scottie considered far less salable and appealing. As far as I know, no paintings or dolls were ever sold.

In March 1941, Zelda wrote to Maxwell Perkins at Scribner's that she would like to publish a book of paper dolls.

"I have painted . . . King Arthur's round table. Jeanne d'Arc and coterie, Louis XIV and court, Robin Hood are under way. The dolls are charming. . . . Would you be kind enough to advise me what publishers would handle such 'literature' and how to approach?" Perkins's response is lost, and a book did not materialize.

That same year Zelda exhibited some paper dolls in the children's room of the Montgomery Museum of Fine Arts.

Zelda continued to suffer periods of mental illness. She was never committed and spent months at a time with her mother in Montgomery. When she felt her health failing she would return voluntarily to Highland Hospital. During her last eight years, Zelda lived quietly as the God-fearing, unpredictable, and valiantly cheerful widow of a forgotten author. If this portrait seems melancholic, it was in her last years that she produced her most vivid and imaginative works. When her first grandson was born in 1946, Zelda gained the perfect audience upon whom to bestow her gifts. The later dolls and the pumpkin portfolio were created for my older brother, Tim. "At the time she died," Scottie explained, "[Zelda] was working on a series of Bible illustrations for her oldest grandchild, then eighteen months."

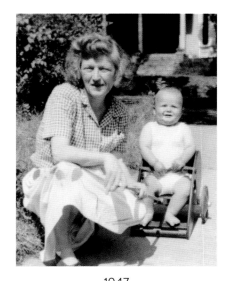

1947
—
Zelda with her grandson Tim Lanahan in Montgomery, Alabama

Zelda died in a fire at Highland Hospital in 1948 and is buried beside Scott in a family plot in Rockville, Maryland. My mother inherited almost all of her art, everything Zelda hadn't given away to friends or to the Montgomery Museum of Fine Arts.

These dolls embody Zelda's lifelong aspirations and creativity, her grace and life force. We know she dreamed of collecting them in a book. And so, at last, here are her paper dolls, fresh from the dressing room, ready to soar across the stage.

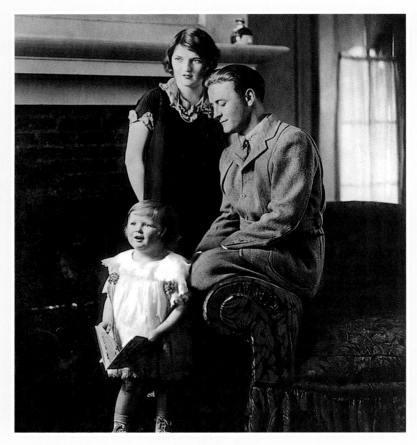

About 1924

The Fitzgerald family poses in Great Neck, Long Island.

Family Dolls

The dolls of Scottie at various ages and Red Riding Hood are Zelda's earliest and date from Scottie's childhood. The family series with everyone in underwear was made later, in 1931, when Zelda was in the hospital in Switzerland. She painted the portraits from memory. "Dear Love," she wrote Scott from Prangins, "I've made Scottie some wonderful paper dolls, you, me and her, but they have no clothes yet—I had such fun imagining you while I drew. I remember every single spot of light that ever gouged a shadow beside your bones so you were easy to make—and I gave you some very doggy green socks to match your eyes. . . ."

A description of David Knight in Zelda's novel, *Save Me the Waltz*, sheds light on Scott's angel costume. "There seemed to be some heavenly support beneath his shoulder blades that lifted his feet from the ground in ecstatic suspension, as if he secretly enjoyed the ability to fly but was walking as a compromise to convention."

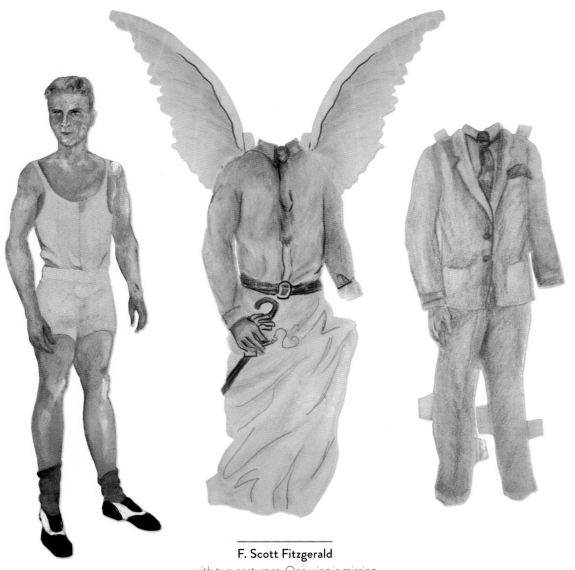

F. Scott Fitzgerald

with two costumes. One wing is missing
on the original. Here the surviving wing is
duplicated.

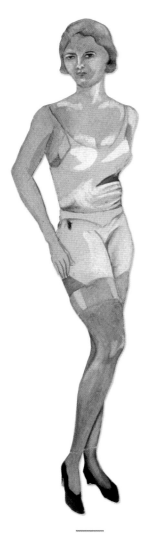

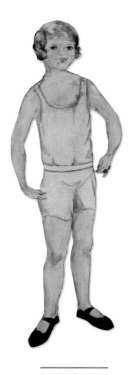

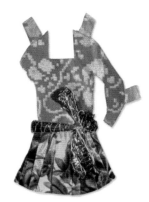

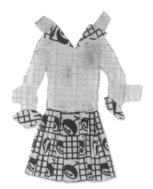

Little Scottie

and two costumes

Zelda

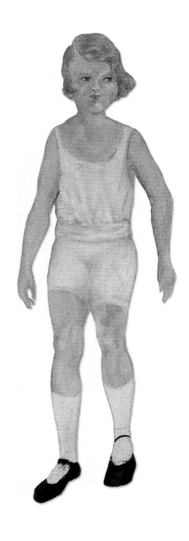

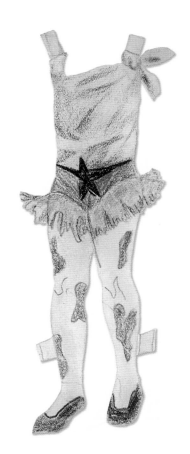

Dancing Scottie

and one ballet costume

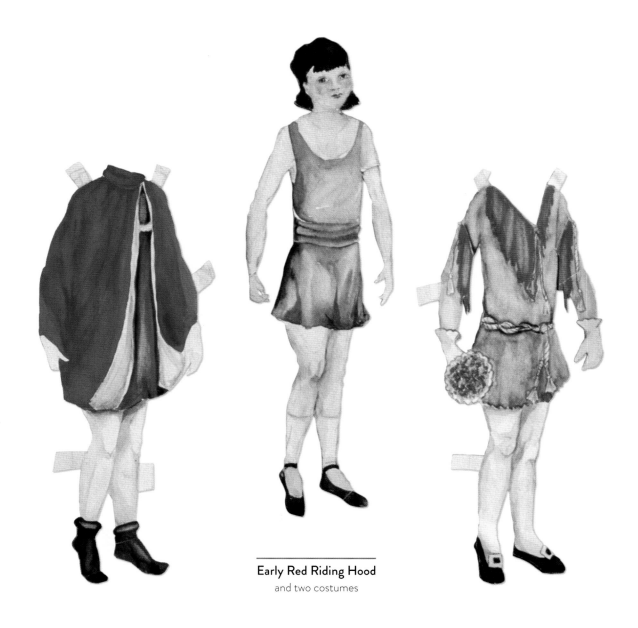

Early Red Riding Hood
and two costumes

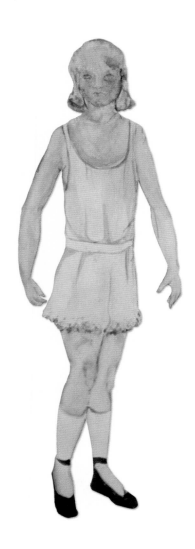

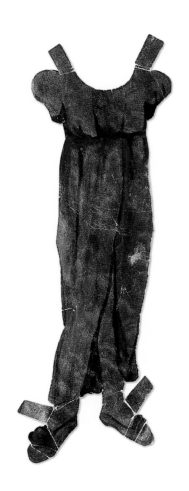

Older Scottie

and one costume made with gold paper foil

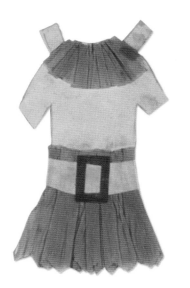

Four costumes
collaged with fabric and
crepe paper

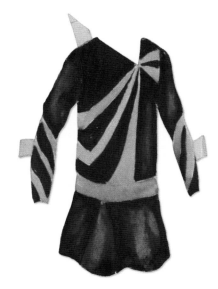

23

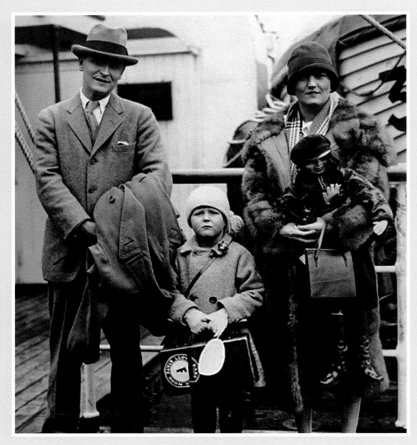

December 1926

Voyaging from Genoa, Italy, to New York aboard the *Conte Biancamano*

Goldilocks & the Three Bears

Like the Fitzgerald family, this fairy tale involves a trio: a father, a mother, and one child. The Bear family have made some porridge, and while they are waiting for it to cool they go out for a walk. Goldilocks, a little human girl, is traipsing through the woods and enters the Bears' house. She tries out the chairs. First she tries Papa Bear's chair. "This is too tall," she says aloud. Mama Bear's chair is too tall as well. Baby Bear's chair is "just right." But suddenly the chair breaks. Next, she tastes the porridge on the table. Father Bear's porridge is "too hot." Mama Bear's porridge is also too hot. Baby Bear's porridge is "just right," and she eats it all up. Now Goldilocks is sleepy, and she tries their beds. Papa Bear's bed is too hard. Mama Bear's bed is too soft. Baby Bear's bed is "just right!" She falls asleep until the bears return. "Someone's been eating my porridge," says Papa Bear. "Someone's been sitting in my chair," cries Baby Bear, "and they have broken it all to pieces." The bears go into the bedroom. "Someone's been sleeping in my bed," says Baby Bear, "and there she is!" Goldilocks awakens in a fright and runs all the way home.

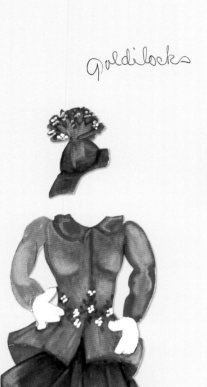

Goldilocks

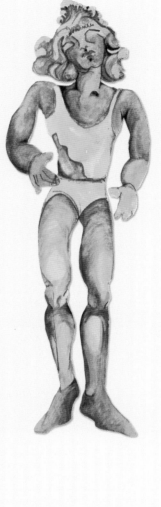

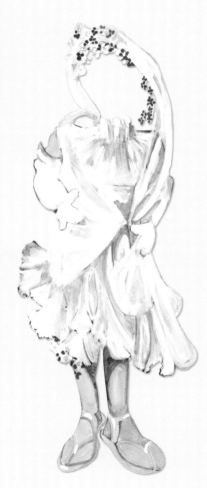

Goldilocks
and two costumes

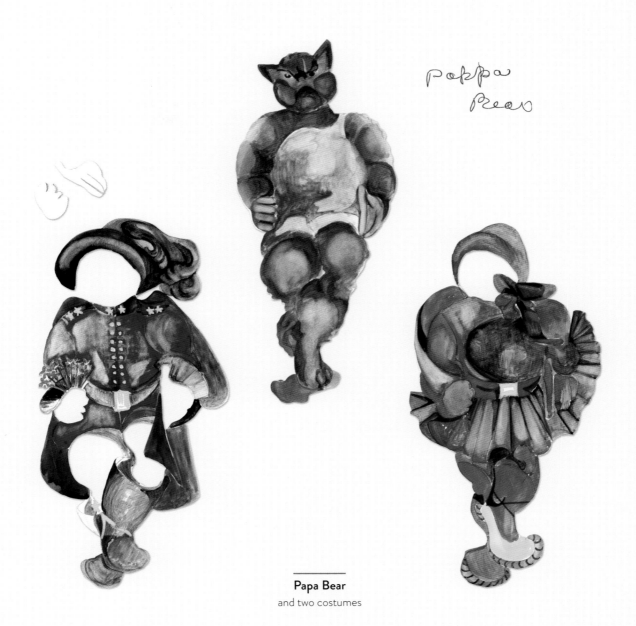

pappa
Bear

Papa Bear
and two costumes

27

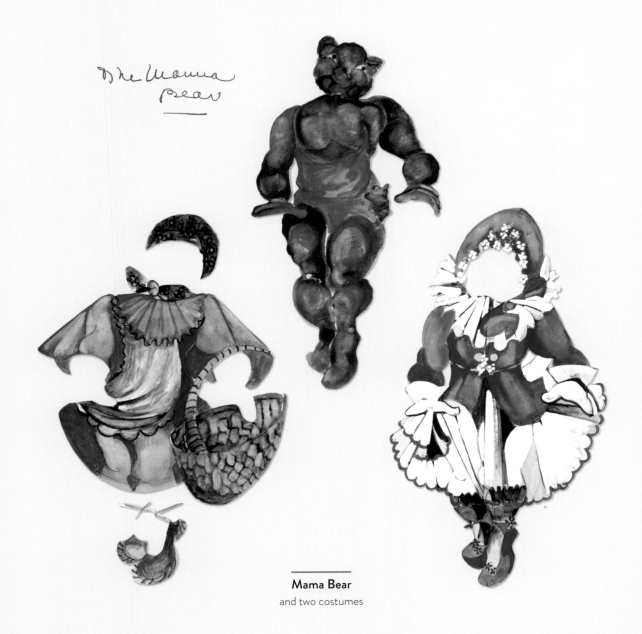

The Mama
Bear

Mama Bear
and two costumes

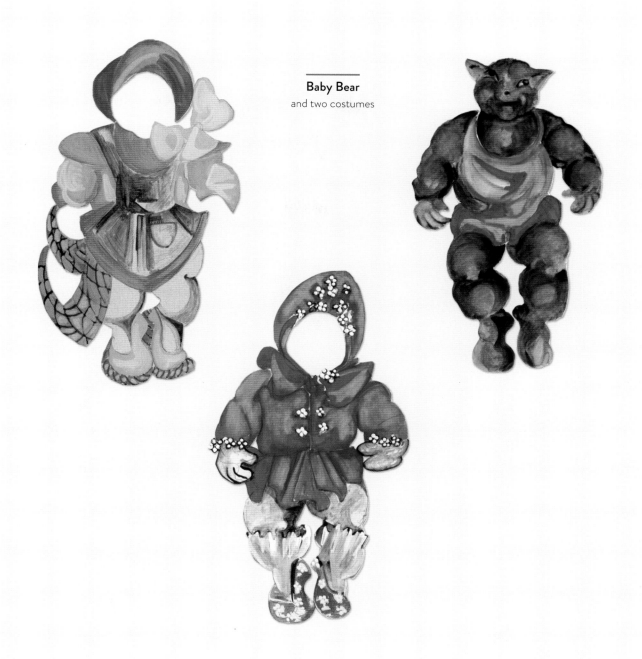

Baby Bear

and two costumes

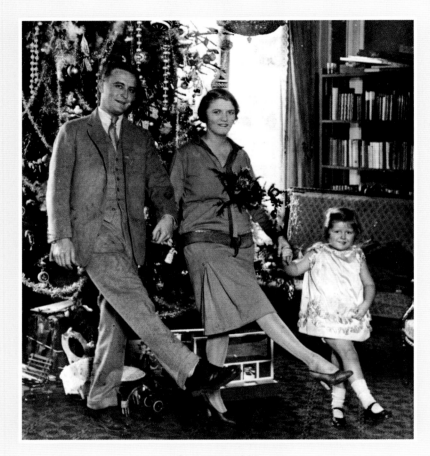

Christmas, 1925

The Fitzgerald family at 14 Rue de Tilsitt, Paris

The Three Musketeers

The Three Musketeers is a novel by Alexandre Dumas, set in 1625, involving King Louis XIII, Queen Anne of France, and their manipulative minister, Cardinal Richelieu. Although the story is based on historical figures, the musketeers' adventures are fictional.

After proving himself in a duel, D'Artagnan, a young and inexperienced gentleman, joins the three dashing Musketeers of the Guard: Porthos (a swashbuckling braggart who loves clothes and money), Aramis (a quiet athlete who wants, someday, to join the church), and Athos (a wise father figure). Together they fight for justice, liberate maligned people, and defend the French crown from a British invasion. D'Artagnan and Madame Constance Bonacieux, seamstress to Queen Anne, are in love, but Mdm. Bonacieux is poisoned before d'Artagnan can rescue her from Milady, an agent of the evil cardinal.

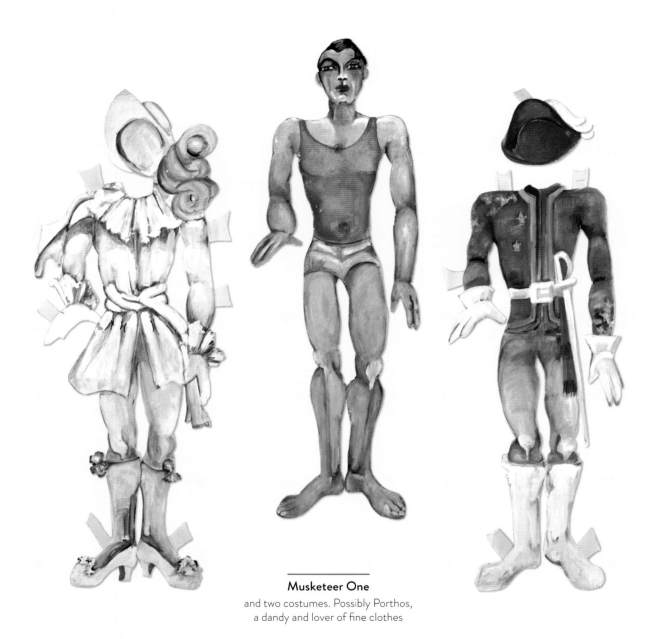

Musketeer One
and two costumes. Possibly Porthos,
a dandy and lover of fine clothes

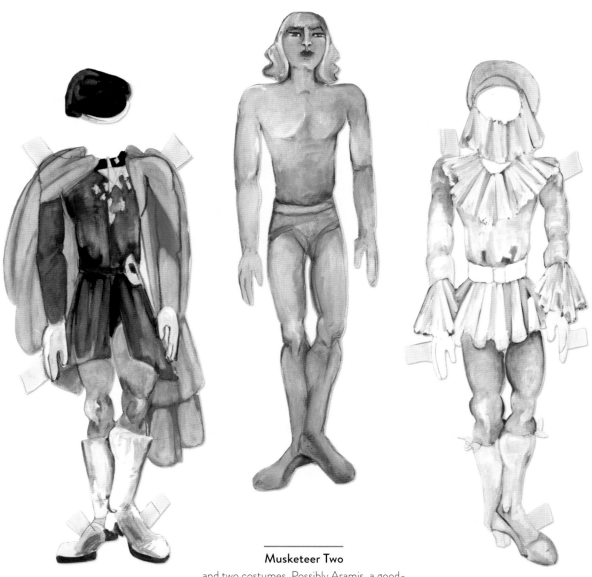

Musketeer Two

and two costumes. Possibly Aramis, a good-
looking ladies' man with a religious background

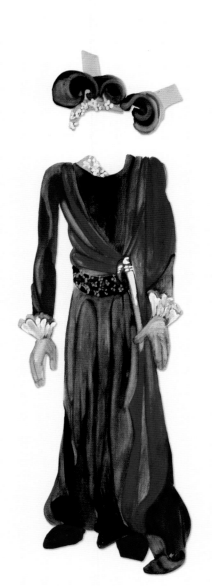
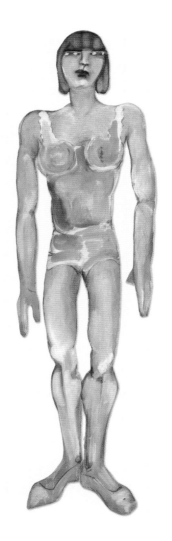
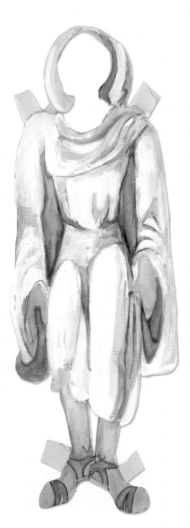

Musketeer Three

and two costumes. Maybe Athos, a drinker
and father figure to d'Artagnan

34

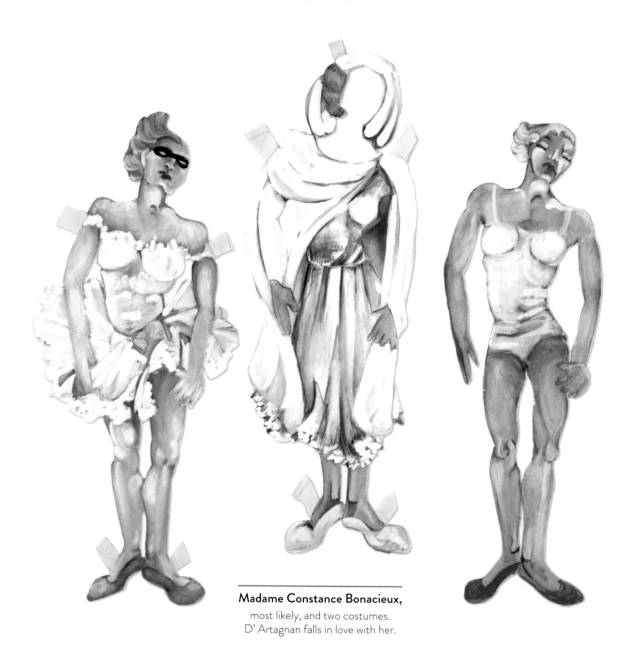

Madame Constance Bonacieux,

most likely, and two costumes.
D' Artagnan falls in love with her.

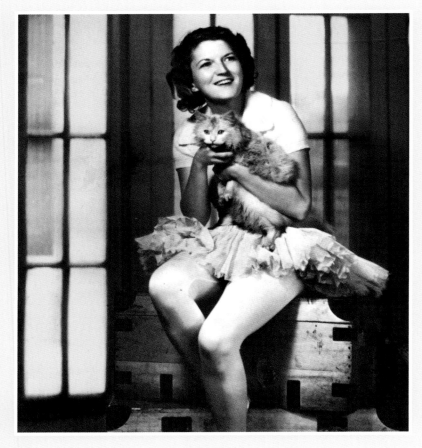

1932
—

Montgomery, Alabama. Portrait for dust jacket of *Save Me the Waltz*

The Court of Louis XIV

The French king Louis XIV's reign, from 1643 to 1715, was one of almost constant warfare. To centralize his government, and to keep an eye on his ministers, Louis commanded thousands of aristocrats, artists, and intellectuals to live at his palace in Versailles. Classical ballet had its roots in the court of Versailles, a milieu of intrigue and masquerade. Louis XIV studied ballet for two decades and occasionally performed. Zelda did not identify the members of Louis XIV's retinue. Here the dolls are named after historical figures, loosely based on period portraits. Some courtesans are identified by a book that belonged to Zelda, *L'Histoire du Costum Féminine Français*, by Paul Louis de Giafferri. Marie-Thérèse d'Austriche is depicted wearing a blue cape lined in ermine. Zelda's costume references the ermine, but the gown sails straight from her imagination. And, like her, the dolls have begun to dance. Many sport ballet slippers. They are muscular, with upturned heads, fully costumed and ready to perform.

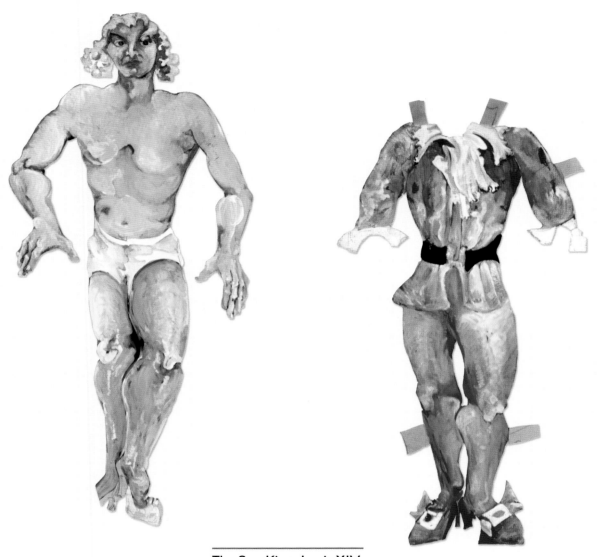

The Sun King, Louis XIV,
and one costume. Absolute monarch of France

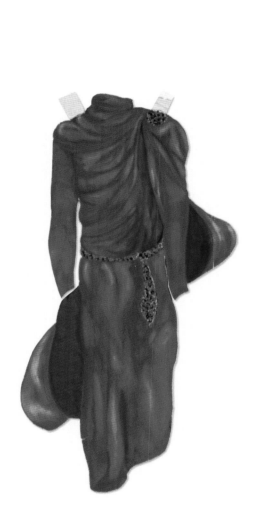

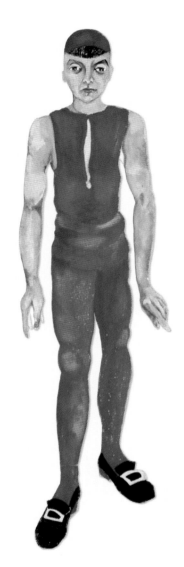

Cardinal Richelieu

and one costume. "The Red Eminence" and chief
minister of France when Louis XIV was a child. He
ruthlessly supported the Catholic monarchy.

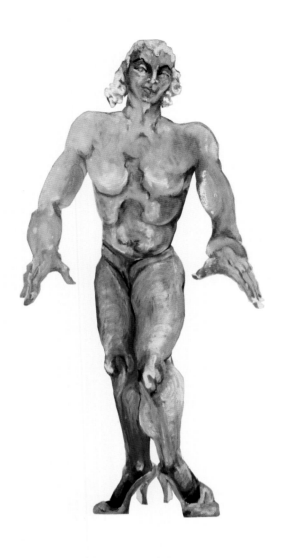

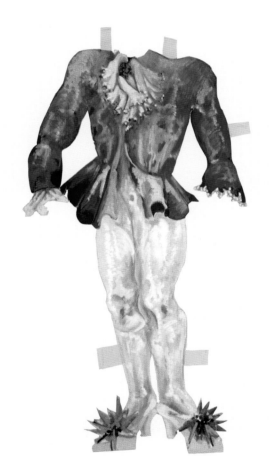

Duc d'Orléans

and one costume. Younger brother of
Louis XIV, gave distinguished service in battle

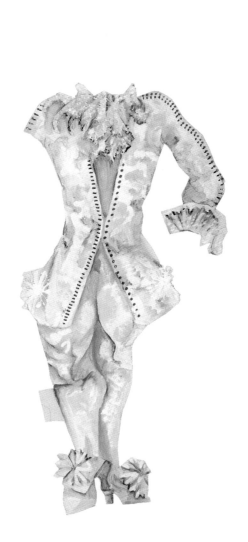

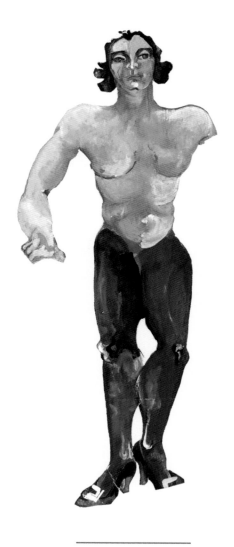

Jean-Baptiste Colbert
and one costume. Lord of Vandières and
Cernay, powerful minister of state

41

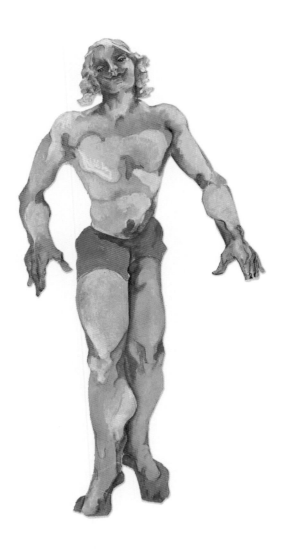
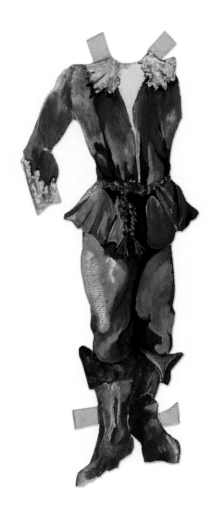

Chevalier de Lorraine

and one costume. The Duc d'Orleans's lover

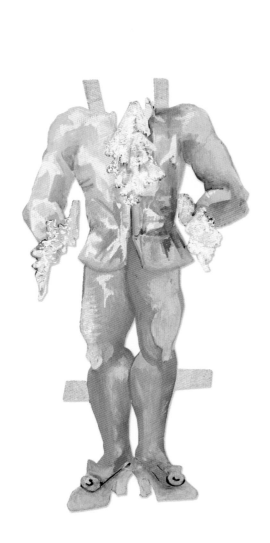

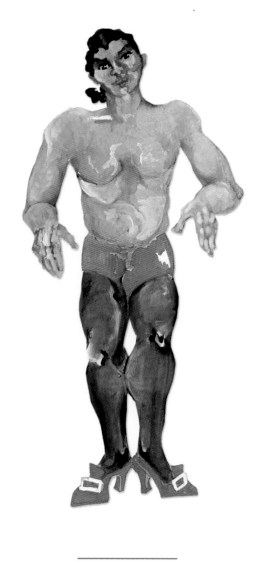

Marquis de Louvois
and one costume. The secretary of state for war

The King's
Guard.

Bourgoine

King's Guard

Monk

The Duc de Bourgogne was the grandson
of Louis XIV. He had dominion over Burgundy
wine, often produced in monasteries and popular
at Versailles. This monk may be a vintner.

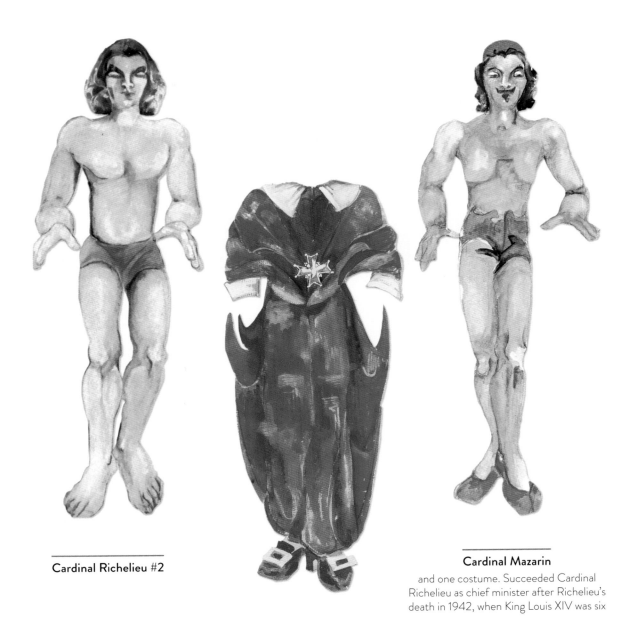

Cardinal Richelieu #2

Cardinal Mazarin
and one costume. Succeeded Cardinal
Richelieu as chief minister after Richelieu's
death in 1942, when King Louis XIV was six

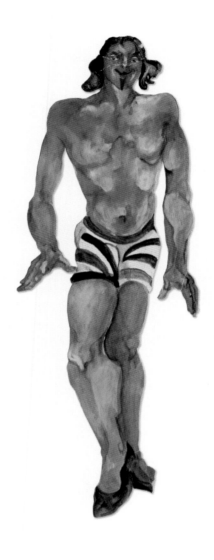

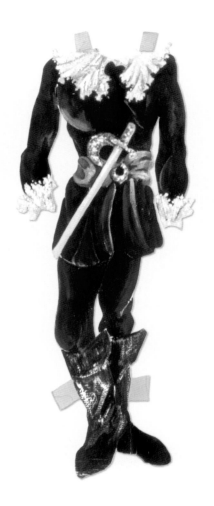

Vicomte de Turenne

and one costume. A valiant fighter and
marshal general of France

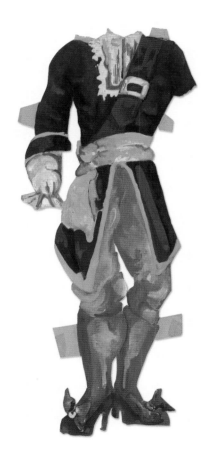
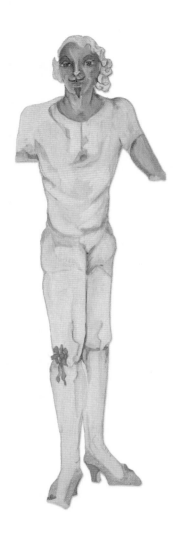

André Le Nôtre

and one costume. Designed the
gardens of Versailles

47

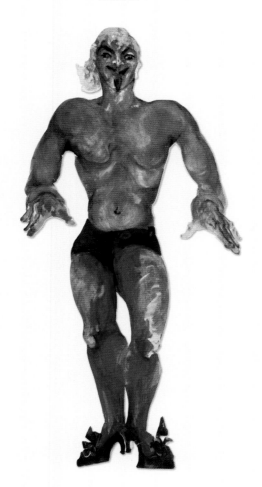

Molière
Playwright, poet, and court historian

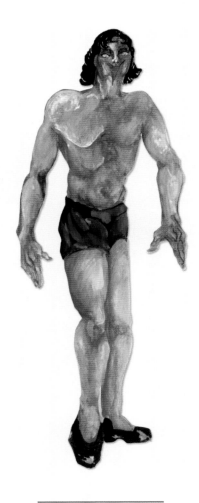

Jules Hardouin-Mansart
Architect of Versailles

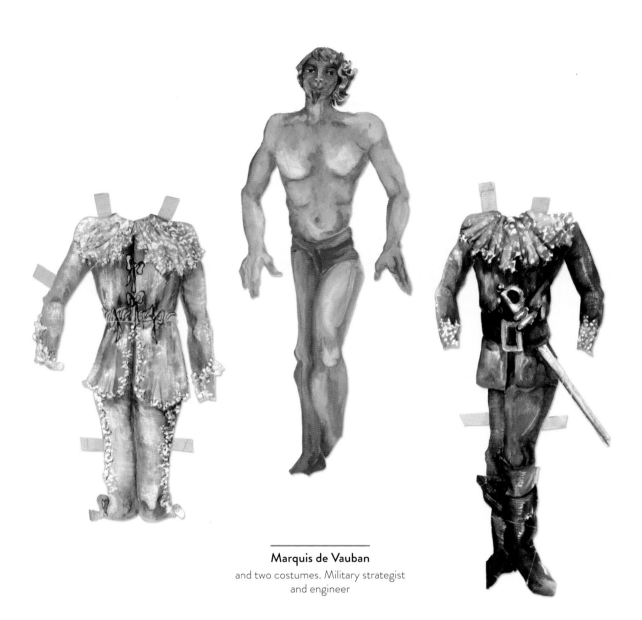

Marquis de Vauban

and two costumes. Military strategist
and engineer

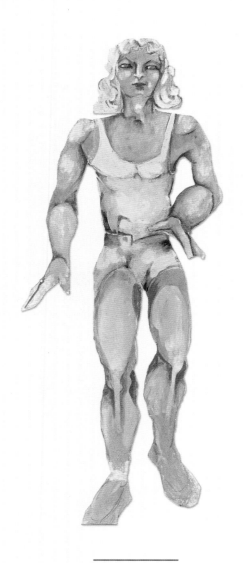
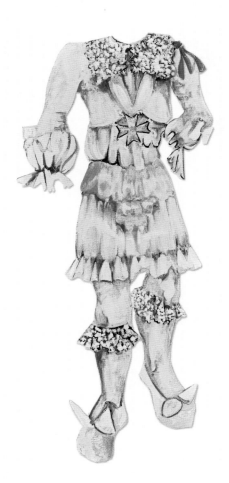

Nicolas Fouquet

and one costume. Marquis de Belle-Île, superintendent of
finances who opposed Mazarin's wasteful borrowing, fomented
a rebellion, and ended up in prison.

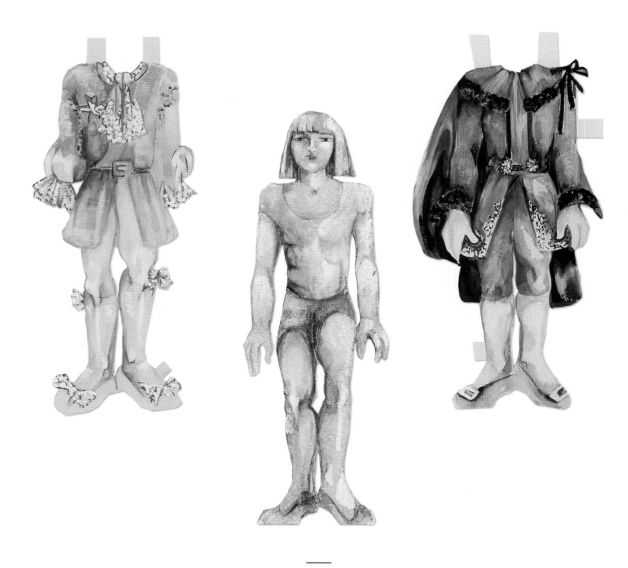

Page

and two costumes

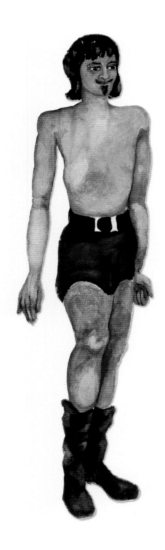

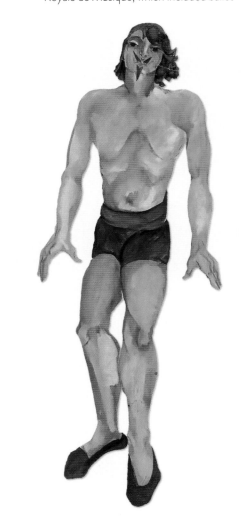

Pierre Perrin
Founder of the Académie d'Opéra

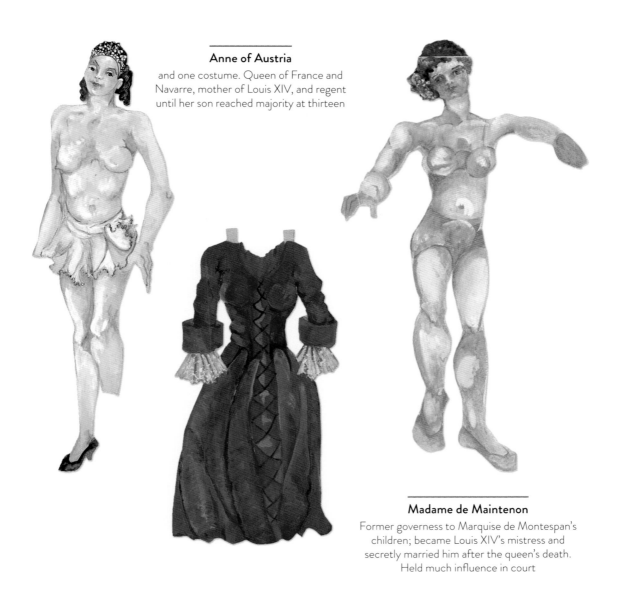

Anne of Austria

and one costume. Queen of France and
Navarre, mother of Louis XIV, and regent
until her son reached majority at thirteen

Madame de Maintenon

Former governess to Marquise de Montespan's
children; became Louis XIV's mistress and
secretly married him after the queen's death.
Held much influence in court

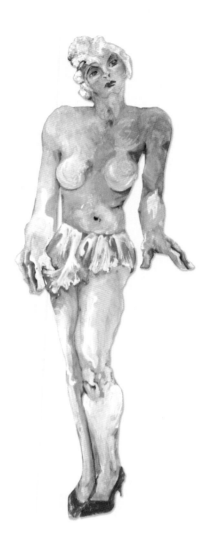

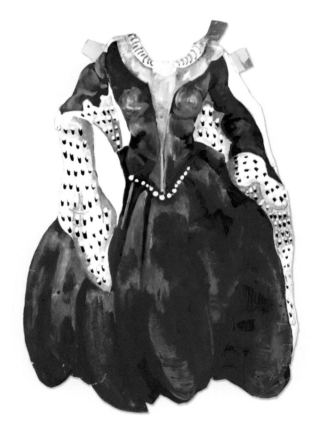

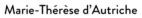

Marie-Thérèse d'Autriche

and one costume. Wife of Louis XIV and mother
of the dauphin, who died before his father, before
taking the throne

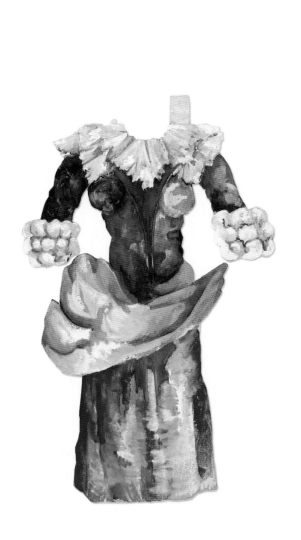

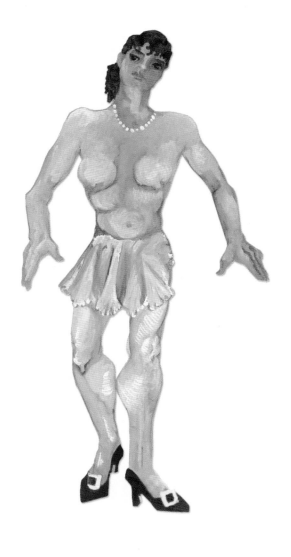

Marquise de Montespan
and one costume. Mistress to Louis XIV and
mother to six of his illegitimate children

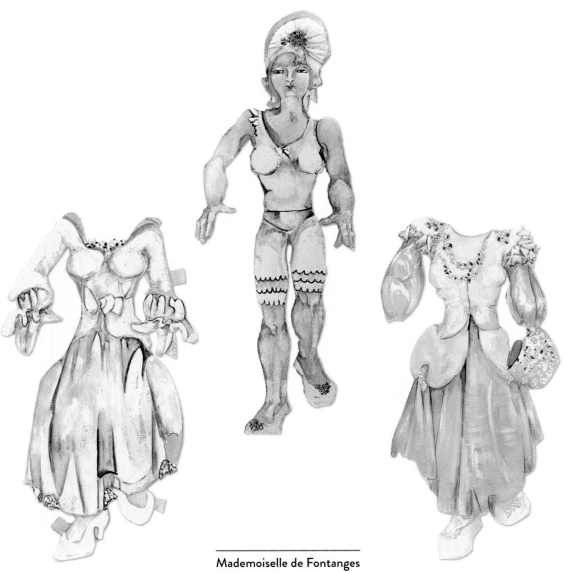

Mademoiselle de Fontanges

and two costumes. Youngest and briefest mistress of
Louis XIV, she was poisoned.

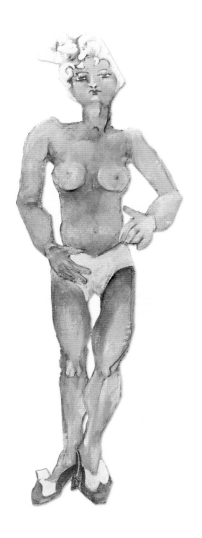

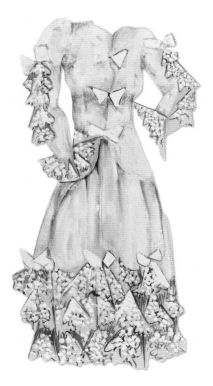

Marion Delorme

and one costume. Had many lovers. Hosted a salon
in Paris for dissenters to the crown. Arrested by
Cardinal Mazarin

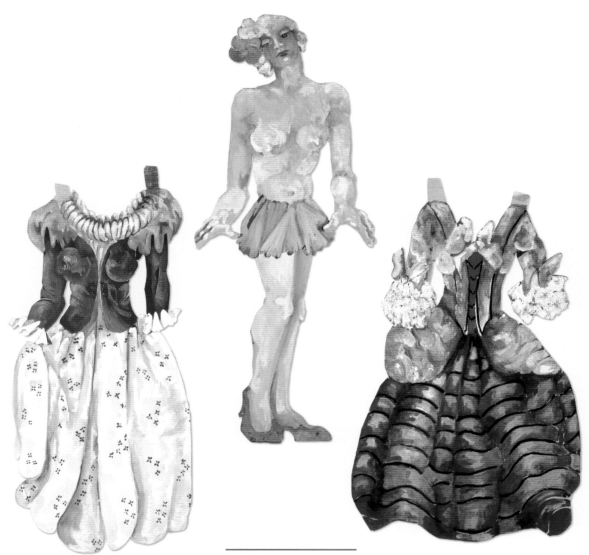

Marie Adélaïde de Savoie
Duchesse de Bourgogne, wife of the dauphin, and
mother of Louis XV, with two costumes

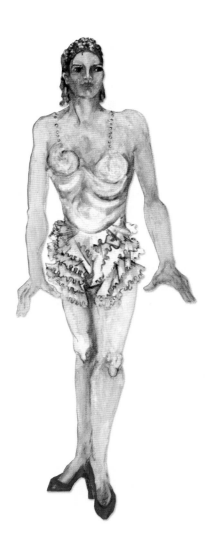

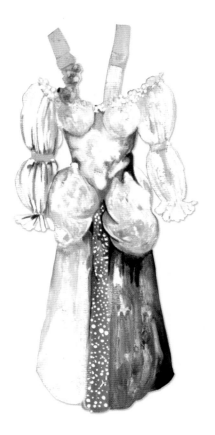

Marquise de Rochebaron

and one costume. Married to the
military marshal of France

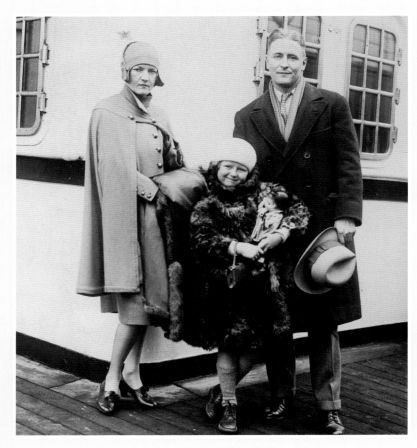

April 1928

The Fitzgerald family crossing to France

Little Red Riding Hood

A young girl, wearing a red cape, sets out through the woods to visit her sick grandmother. Her mother told her to stay on the path, but Red Riding Hood wanders into the forest. A wicked wolf sees her and tricks her into telling him where she is going. He suggests she pick some wildflowers for her grandmother, which gives him time to scamper to Grandmother's house and eat her in one big bite. Quickly he puts on the grandmother's clothes, then hops into bed and waits for Little Red Riding Hood. When the girl arrives, she is worried. Her grandmother looks strange.

"Grandmother, what a deep voice you have!" Red Riding Hood says.

"The better to greet you with," says the wolf.

"Grandmother, what big eyes you have!"

"The better to see you with," says the wolf.

"But, Grandmother, what big teeth you have," says Little Red Riding Hood.

"The better to *eat* you with," says the wolf as he leaps out of bed. He is about to devour Little Red Riding Hood when she screams. Two woodsmen, cutting trees nearby, hear the scream and burst into the house. They chop open the wolf with an ax, and Grandmother is released from his belly, alive.

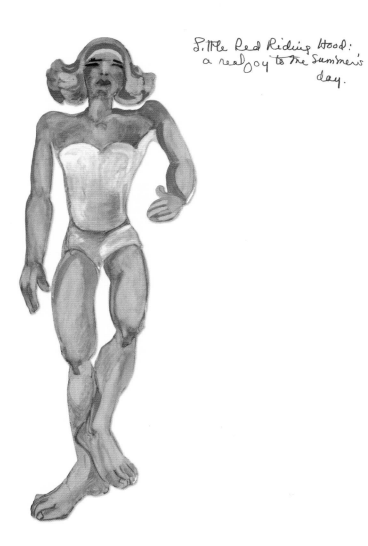

Little Red Riding Hood: a real joy to the summer's day.

Little Red Riding Hood

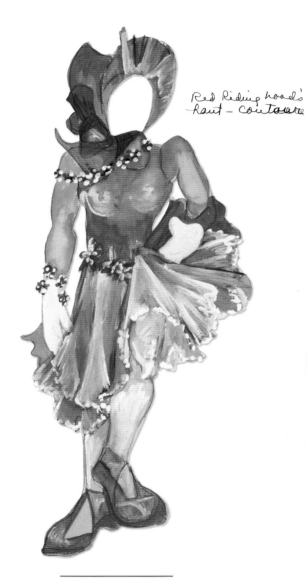

Red Riding hood's
haut - couture

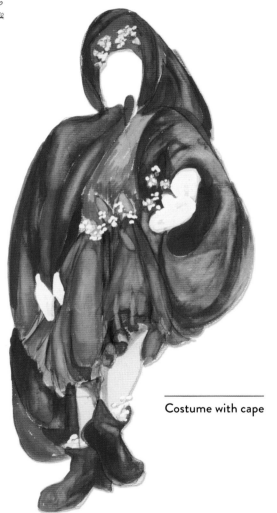

Red Riding Hood in
academic vein

Costume with cape

Costume with bonnet

"Red Riding Hood's
haute-couture"

63

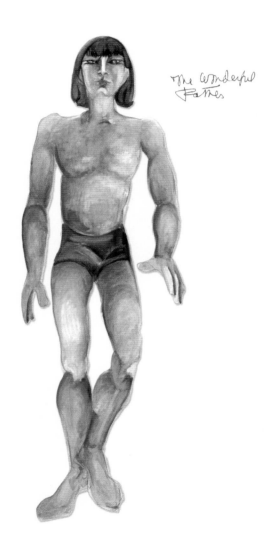

The Wonderful
Fathes

The Father

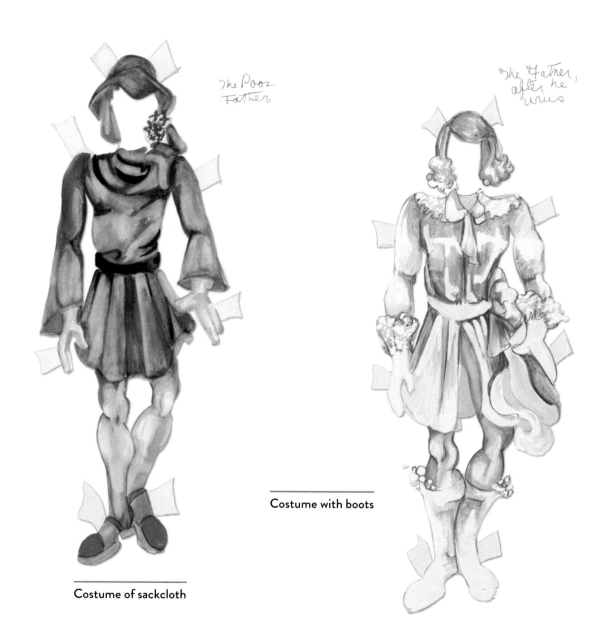

The Poor
Father

The Father,
after he
wins

Costume with boots

Costume of sackcloth

65

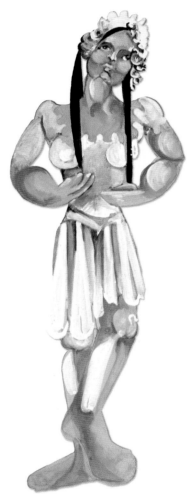

Grandma:
blissfully resigned to
the wolf-age.

Grandmother
and two costumes

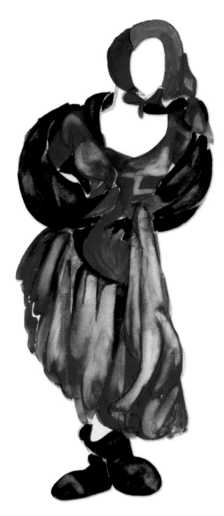

Grandma

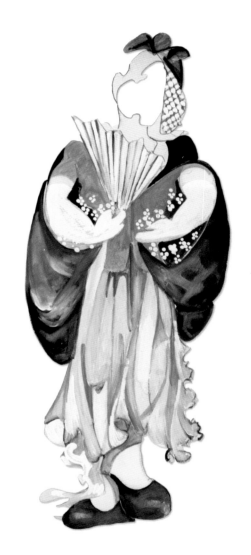

The bigger and badder of wolves.

Costume with weapons

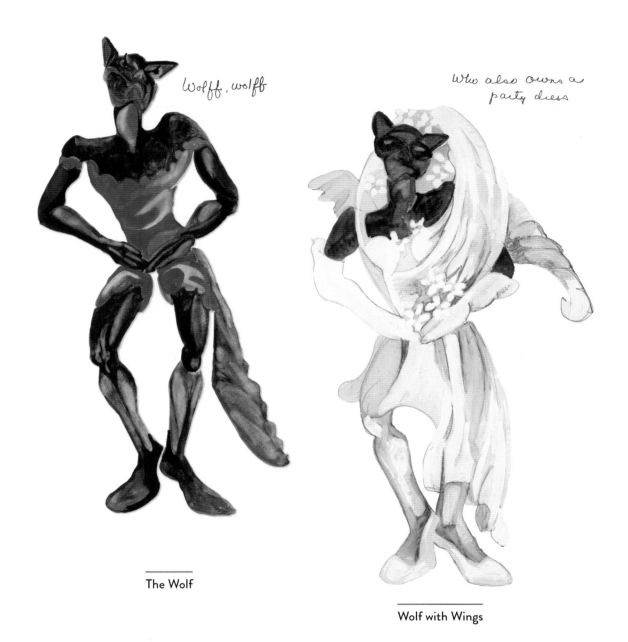

Wolff, wolff

Who also owns a
party dress

The Wolf

Wolf with Wings

69

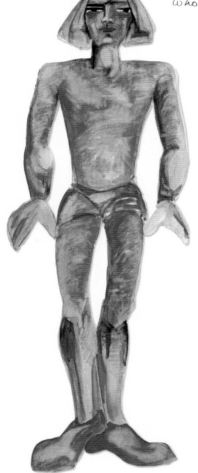

a wood cutter who could cut would

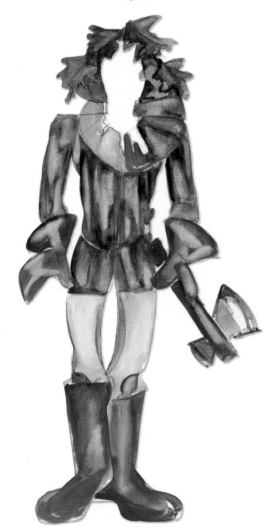

wood - cutter

Woodcutter One

and one costume

wood-cutter 2

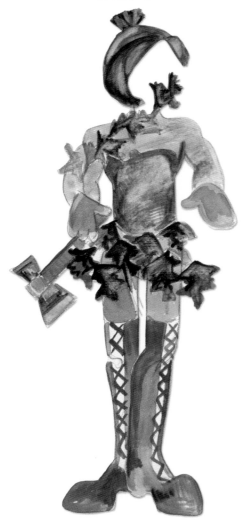

This is a
Statwat wood-
cutter. 2

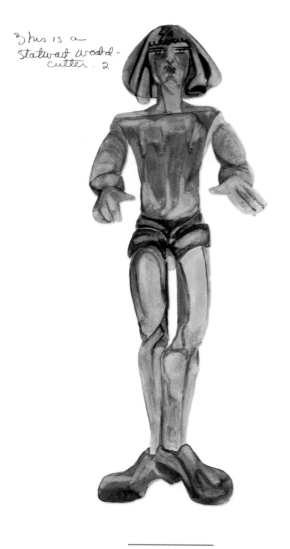

Woodcutter Two

and one costume

71

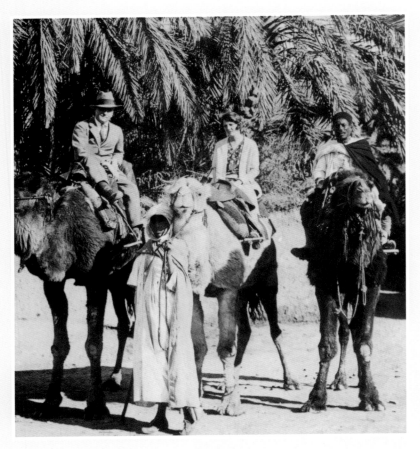

1929

"It was a trying winter and to forget bad times we went to Algiers."
—Zelda Fitzgerald

King Arthur
and the Knights of the Round Table

The legend of King Arthur and the Knights of the Round Table is based on an ancient fable dating to the twelfth century. Many legends are woven into this tale. Merlin, a powerful magician, has placed a magic sword, Excalibur, into a stone and decreed that whosoever can pull it out will become the rightful king of Camelot. Years later, young Arthur extracts Excalibur and is declared king. He invites twelve of England's finest knights to sit at his Round Table. They serve gallantly, and at least five knights, led by Galahad, go to Europe to seek the Holy Grail, a magical cup from which Jesus drank at the Last Supper—and that his father, Joseph, used to catch Jesus's blood at the Crucifixion. Galahad succeeds in carrying the Grail to England. A huge battle ensues, during which several knights of the Round Table are killed. The Grail is never seen again. A gravely wounded Arthur is transported to the secret island of Avalon, hidden in mist, where he may—or may not—have died.

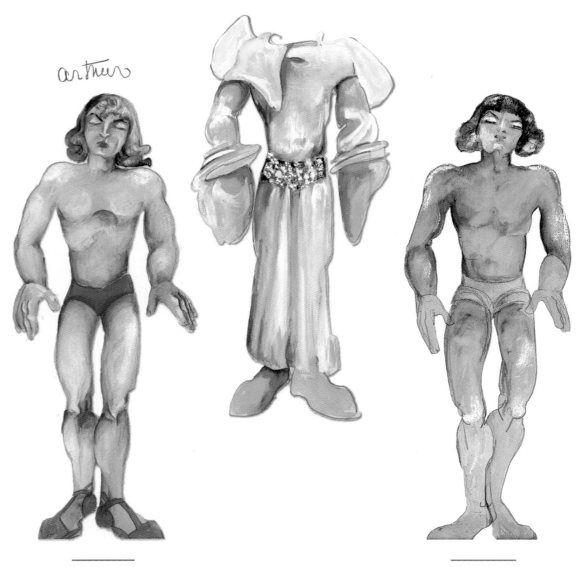

arthur

King Arthur
and one costume for nonmilitary matters

Male Figure,
who may be a younger Arthur

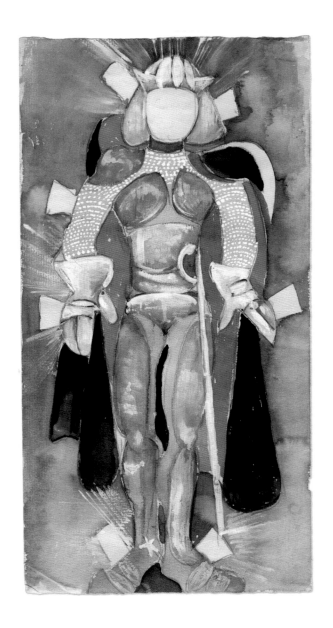

Arthur's Armor

with his enchanted sword,
Excalibur

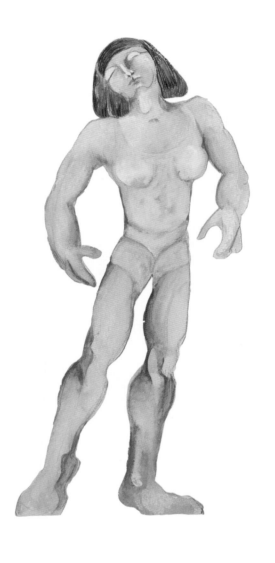
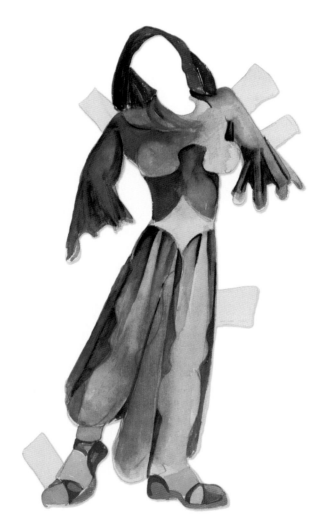

Morgan le Fay

and two costumes. The sorceress who
carries Arthur to Avalon upon his death

Morgan Le
Fay —

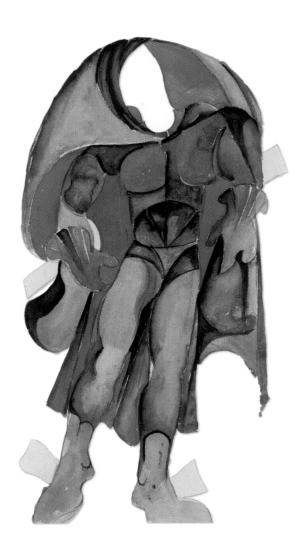

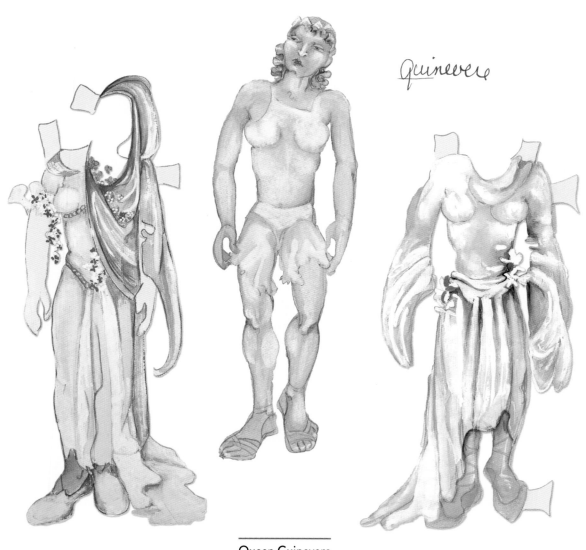

Guinevere

Queen Guinevere

and two costumes

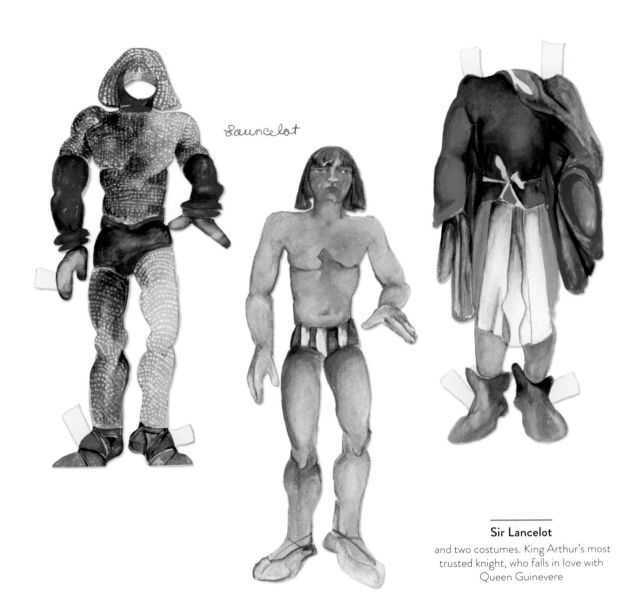

Launcelot

Sir Lancelot

and two costumes. King Arthur's most
trusted knight, who falls in love with
Queen Guinevere

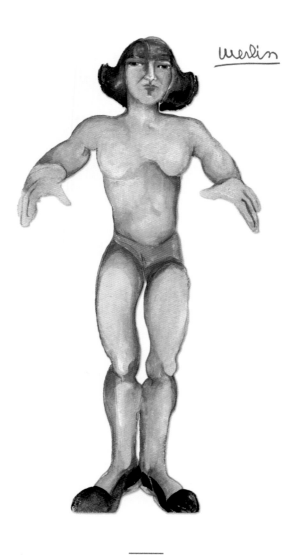

Merlin

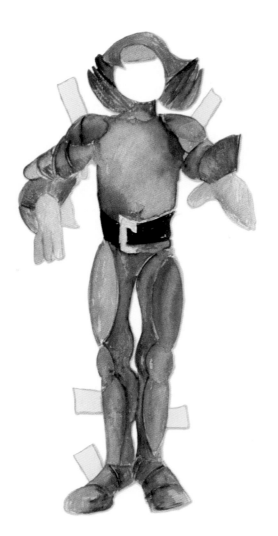

Merlin

and two costumes. Wizard with magic
powers. Advisor to King Arthur

80

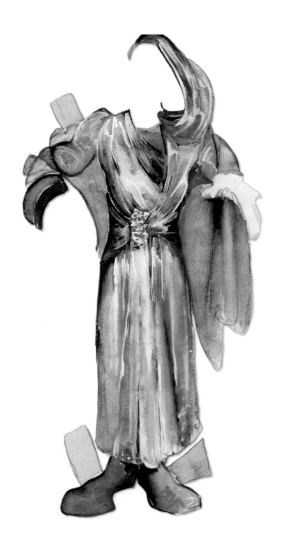

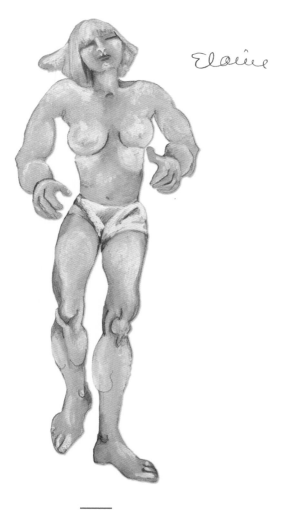

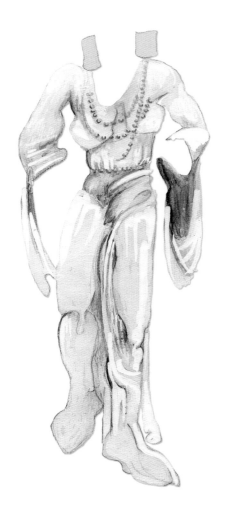

Elaine

Elaine

and two costumes. Morgan le
Fay's older sister. Elaine is
hopelessly in love with Lancelot.

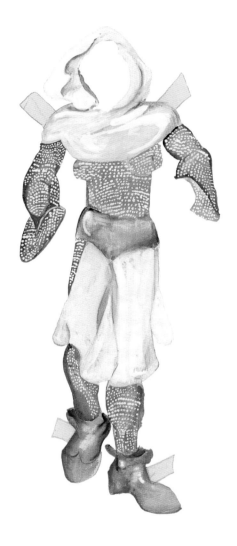

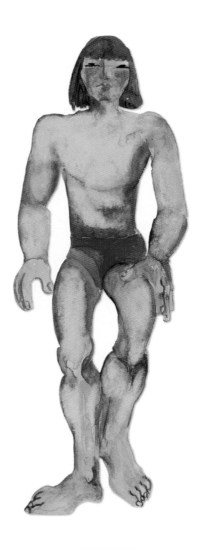

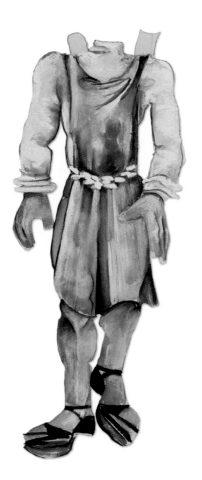

Sir Gawain

and two costumes. A knight of the Round
Table, Gawain is King Arthur's nephew and
heir to the throne of Camelot.

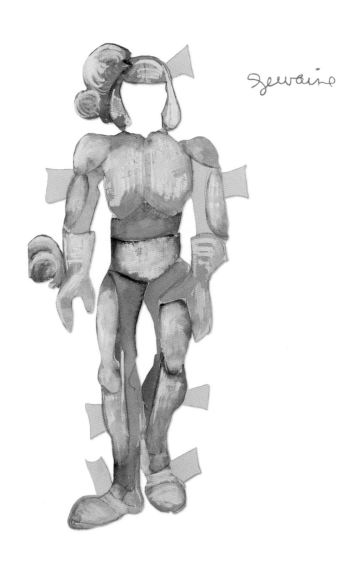

Gervais

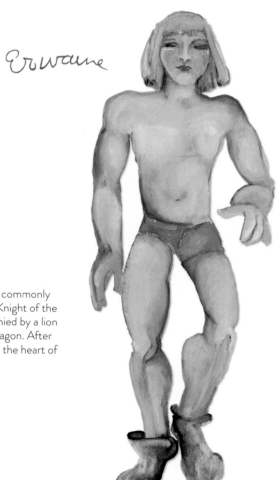

Erwaine

Erwaine

and two costumes. More commonly
known as Sir Yvaine, "The Knight of the
Lion," Erwaine is accompanied by a lion
that he rescued from a dragon. After
jousts and exploits, he wins the heart of
Laudine.

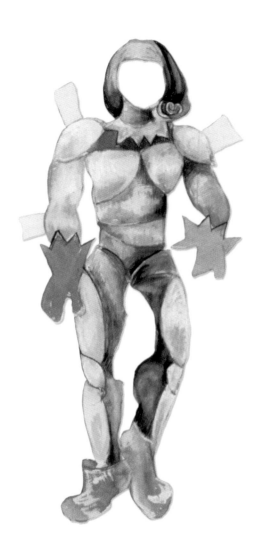
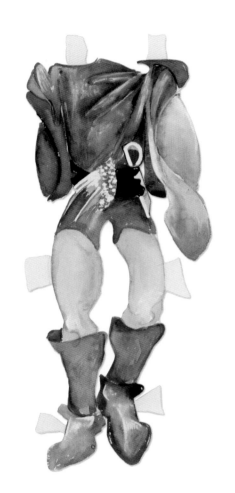

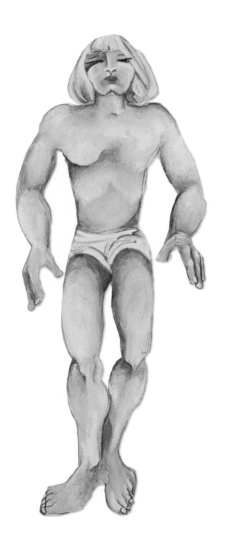

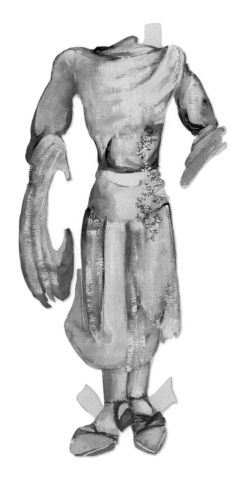

Sir Percival

and two costumes. Percival, of lowly birth,
saves King Arthur in battle. For his gallant
deed, the king knights him.

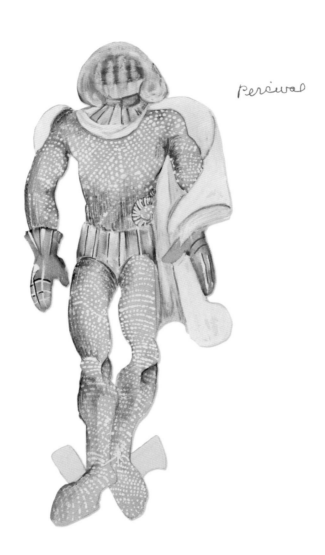

Percival

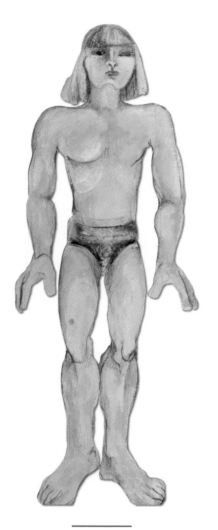

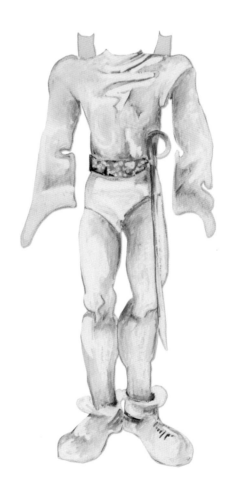

Sir Galahad

with two costumes and his sword, Galantine.
The son of Sir Lancelot and Elaine, Galahad is
the purest of the knights and the most valiant.
He becomes one of three knights to discover
the Holy Grail.

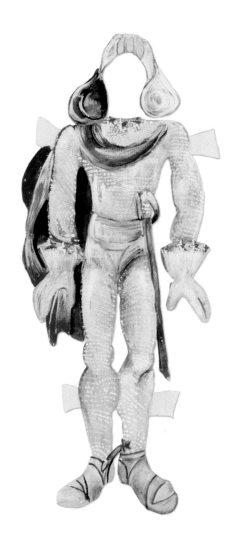

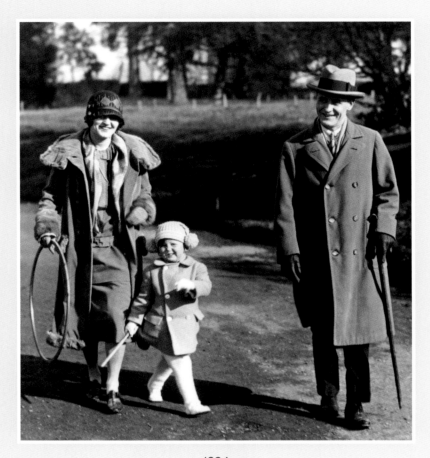

1924

The Fitzgerald family in Rome

Hansel & Gretel

Hansel and Gretel are sent into the woods by their cruel stepmother because there is not enough food to feed the family. The children drop a trail of bread crumbs to find their way home, but by evening the birds have eaten up the crumbs. They soon discover a house made of gingerbread and candy. Hungrily they eat pieces of the doorway and windows. "Nibble, Nibble, little mouse. Who is nibbling at my house?" says an old woman, who is really a witch. She invites the children inside for breakfast, then throws Hansel into a cage. "I will fatten you up," says the witch gleefully, "and then I shall eat you." Now, witches have poor eyesight, so each day when the witch reaches into the cage to feel Hansel's arm, he holds out a bone. After a few weeks, when Hansel's arm remains thin, she grows impatient. "Build a big fire in the oven," she tells Gretel. "I'm going to eat the boy now."

"But I'm not sure how to make the fire hot enough," says Gretel. When the witch leans into the oven, Gretel pushes her into the flames and latches the door. She frees Hansel, and they return home to discover their stepmother has died. Their father is overjoyed to see them.

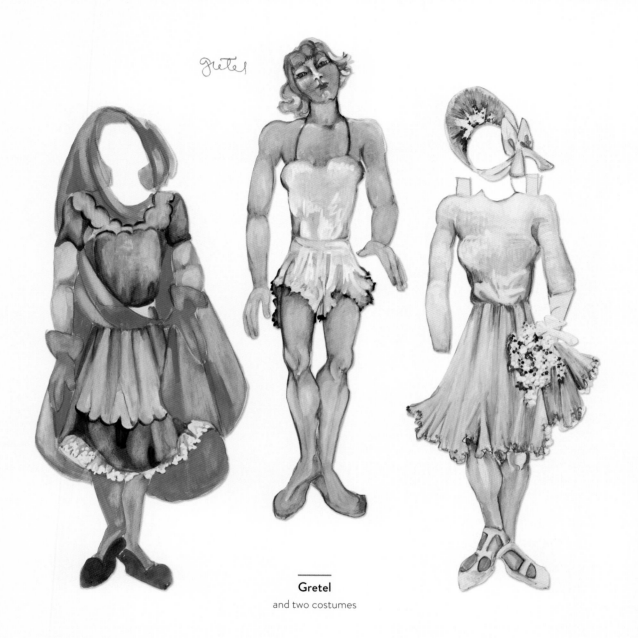

gretel

Gretel

and two costumes

94

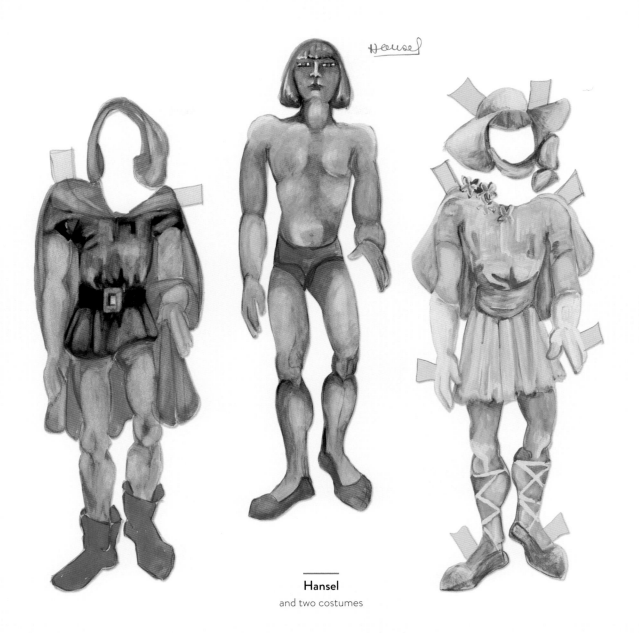

Hansel

and two costumes

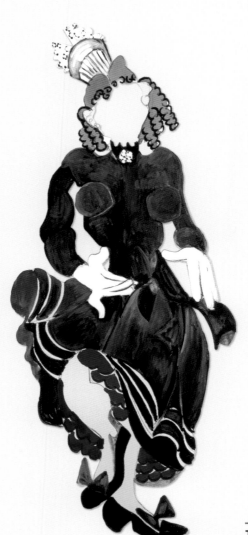

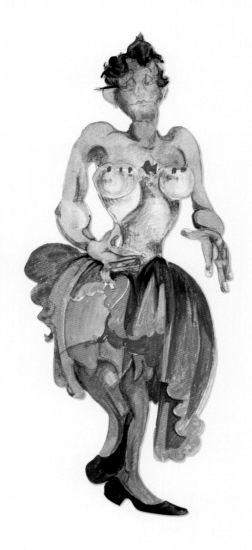

The Wicked Witch

and one costume

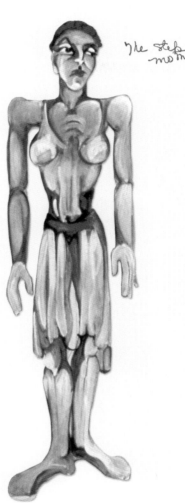

The Step
mother

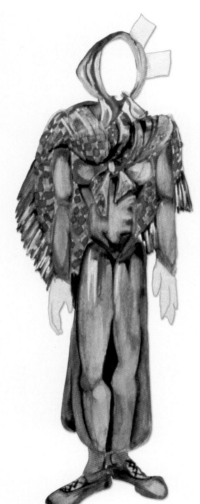

The Stepmother

and one costume

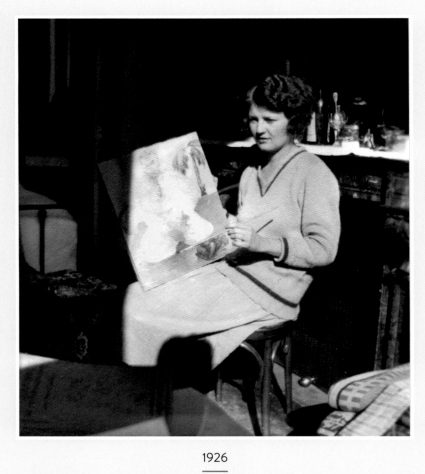

1926

Zelda painting a portrait of Scott, Salies-de-Béarn, France

Assorted Dolls

Between stays at Highland Hospital, Zelda lived at her mother's house in Montgomery, Alabama, and used a converted shed in the backyard as her studio. When Zelda died, the Sayre family held a yard sale of all the work in her studio, including sketch pads containing numerous paper dolls. A few were sold, but the next day the remaining work was burned. These assorted pages contain incomplete series, some from the rescued sketchbooks. Robin Hood, who Zelda once mentioned to Maxwell Perkins, disappeared. Three figures—the Prince, the Good Fairy, and the Fairy—exhibited at the Montgomery Museum of Fine Arts in 1974, are scanned from the museum catalog but have subsequently vanished. Zelda herself gave Hansel and Gretel to the Montgomery Museum of Fine Arts, along with several members of King Arthur's court. She also gave a few unidentified figures to friends. Although the groupings remain a mystery, here the power of Zelda's costumes reaches a crescendo. These stand-alone dolls serve as dashing, romantic archetypes from our collective unconscious, Jungian heroes equipped for their mythical journeys.

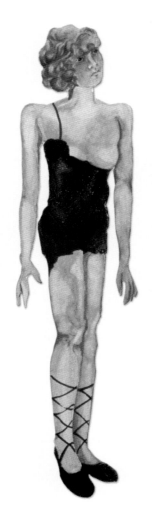

Joan of Arc

and two costumes. She lived around 1412–1431 and led the French army of King Charles VII to victory by defeating England's King Henry V and the Duke of Burgundy. Two years later, Joan was captured in battle. An English court accused her of practicing witchcraft and of dressing like a man. In Rouen, at the age of nineteen, she was burned at the stake. Four hundred years later she was declared a saint.

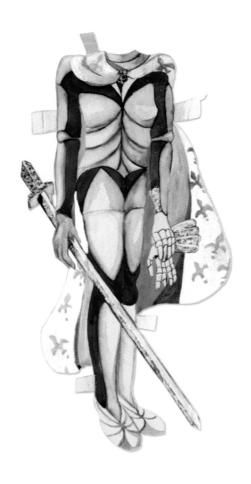

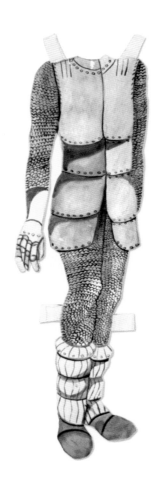

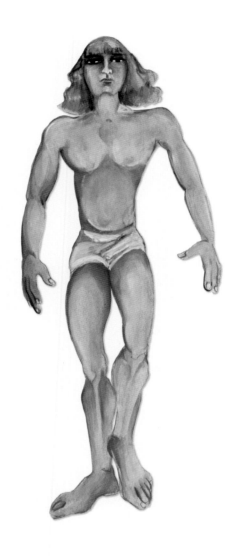

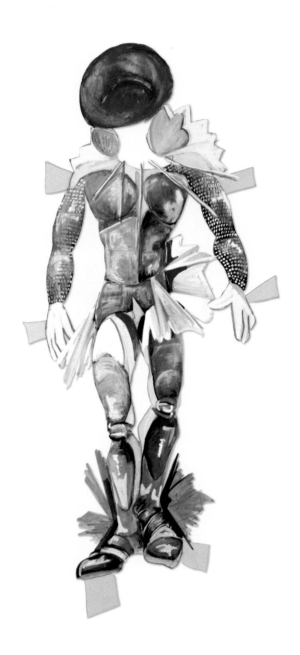

The King

and two costumes

The King

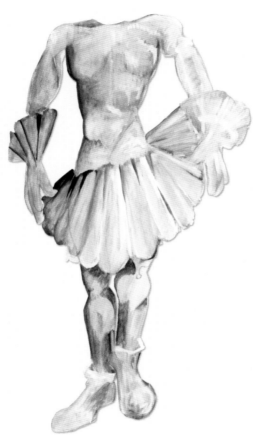

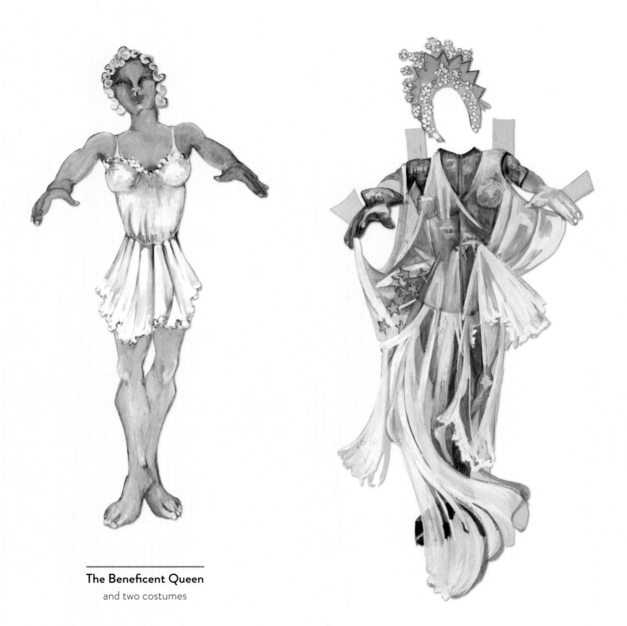

The Beneficent Queen

and two costumes

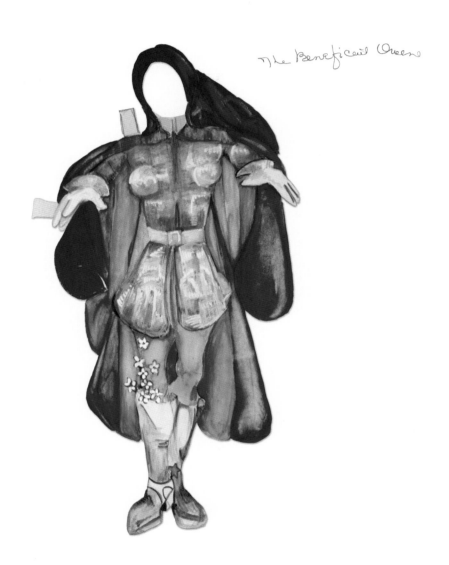

The Beneficial Queen

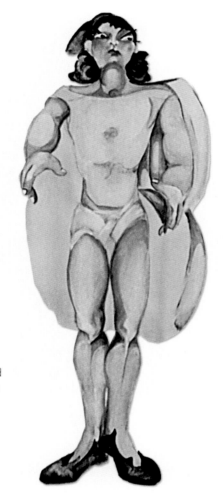

The Prince

and two costumes. The Prince doll appeared in an exhibition catalog in 1974 and has not been seen since.

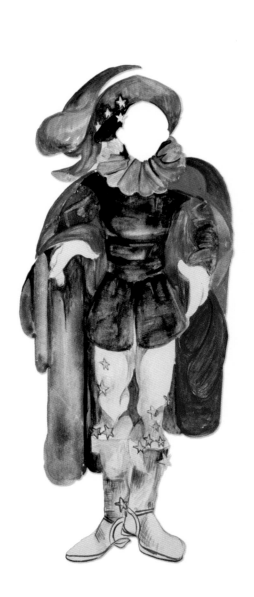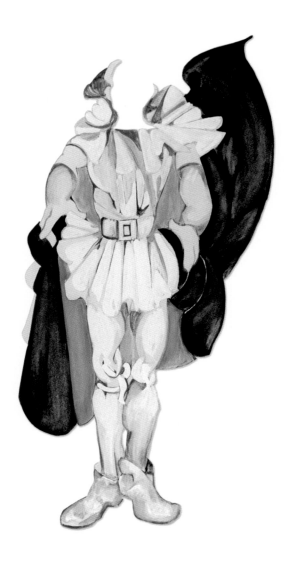

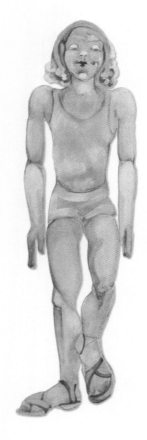

The Prince's Page

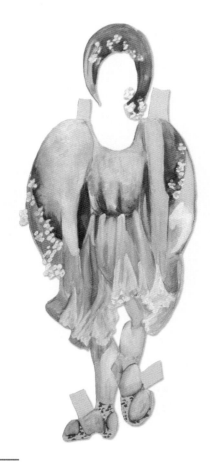

The Prince's Page
and one costume

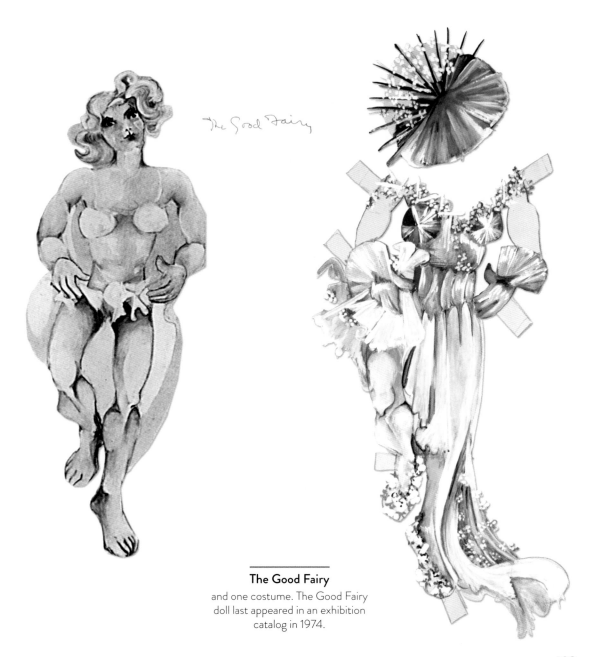

The Good Fairy

The Good Fairy
and one costume. The Good Fairy
doll last appeared in an exhibition
catalog in 1974.

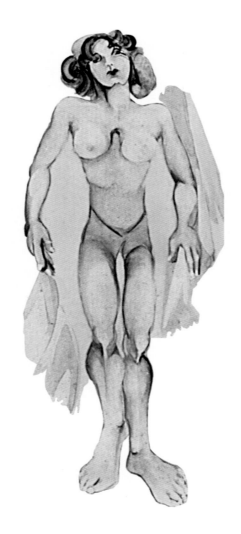

The Fairy

and two costumes. Last seen in an
exhibition catalog, 1974

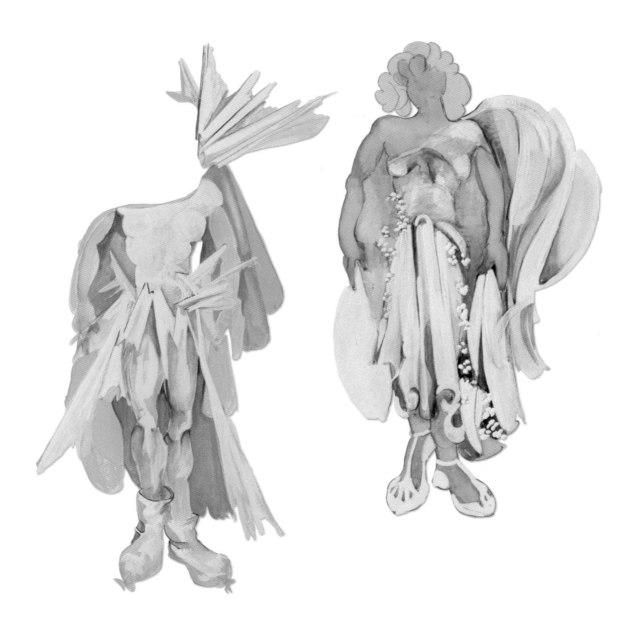

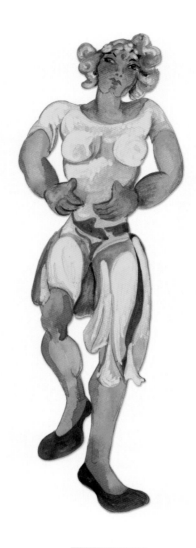

Young Woman

and two costumes found in one of
Zelda's sketchbooks

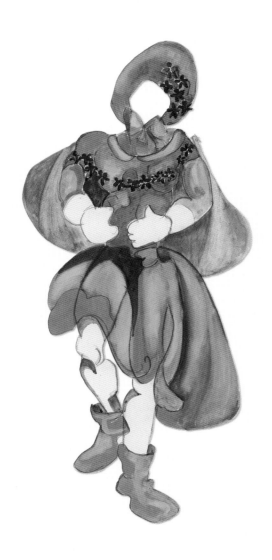

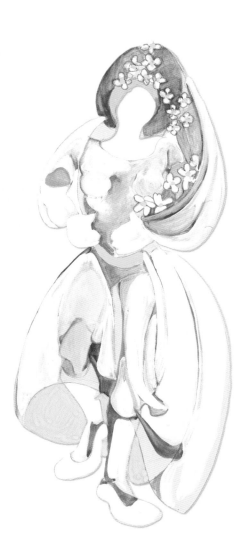

113

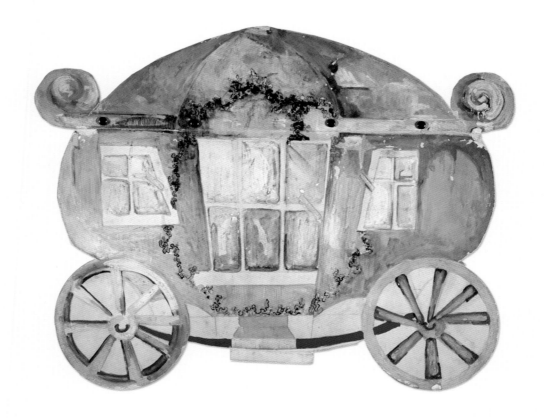

Pumpkin Coach Portfolio (front)
Zelda made this coach for her grandson
Tim Lanahan, to hold a collection of paper
dolls, most likely Cinderella.

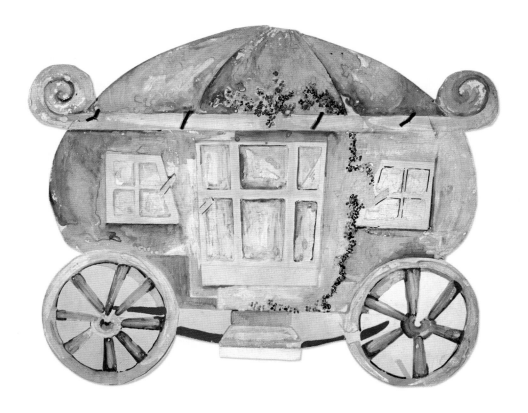

Pumpkin Coach Portfolio (back)
Opens with brass brad hinges

Credits

All photos and artwork are from the collection of the author, except as noted below:

Princeton University, Visual Materials Division, Department of Rare Books and Special Collections, photos, Scott and Zelda, pp. vi, xii; Zelda pregnant, p. 2; Zelda and Scottie, p. 3; clipping, p. 4; Rome, p. 5; Dollhouse, p. 8; Isle of Palms, p. 13; Zelda with grandson, p. 15; family, p. 16; Shipboard, p. 24; Zelda, p. 36; shipboard, p. 60; Rome, p. 92

"The Spell of F. Scott Fitzgerald Grows Stronger," *Life* magazine, February 16, 1959, p. viii

"Scott Fitzgerald and His World," Arthur Mizener, Putnam, 1972, La Paix, p. 11; beach, p. 12

Cecilia Lanahan Ross, Family Dolls, pp. 18–23

Samuel J. Lanahan, Lampshade, pp. 6–7; Sir Lancelot, p. 79

Cecilia Ross Lee, Red Riding Hood, pp. 62–63, 67–71; Stepmother, p. 97

Christian Scott Ross, King and costumes, pp. 102–103; Pumpkin Coach portfolio, pp. 114—115

Yale University, Yale Collection of American Literature, Beinecke Rare Book and Manuscript Library, Louis XIV, pp. 41–43, 47, 52 (right), 53, 55

Property of a Private American Collector (sold through Sotheby's), members of the Louis XIV's court, pp. 45, 50, 51, 56, 57

Montgomery Museum of Fine Arts, King Arthur, pp. 80–81, 84–91; Hansel, Gretel, and costumes, pp. 94–95; "Zelda/Zelda Sayre Fitzgerald Retrospective," Montgomery Museum of Fine Arts, 1974, missing original figures, pp. 106, 109 (left), 110

Nancy and Rick Anderson, Wonderful Father, pp. 64–65

Ann Gassenheimer and Pat Gallagher, Monk, p. 44

Peggy Mussafer, Richelieu, p. 45

Mary Morant, Male Figure, p. 74

Thank you to my family for sharing their dolls and enthusiasm: John Douglas, Cecilia Ross, Ceci Lee, Scott Ross, Sam Lanahan, Nathan Hazard, Zachary Hazard, and Blake Hazard. Much appreciation to Dorian Karchmar at WME, Sarah Graves at MMFA; Don Skemer and Anna Lee Pauls at Princeton; Elizabeth Sudduth at USC; Shawn Sudia-Skehan, Anne Margaret Daniel, and Nancy Kuhl at Yale—all for facilitating this project with grace. And a special thanks to the awesome and creative people who made this book happen: Kara Watson and Nan Graham at Scribner, and Tina Christensen at Scoula Group.